# THE SKY'S THE LIMIT

*Fiction*

The Sterile Cuckoo
The Wizard of Loneliness
The Milagro Beanfield War
The Magic Journey
The Nirvana Blues
A Ghost in the Music
American Blood

*Nonfiction*

If Mountains Die (with William Davis)
The Last Beautiful Days of Autumn
On the Mesa
A Fragile Beauty

# THE SKY'S THE LIMIT

## A DEFENSE OF THE EARTH

### TEXT AND PHOTOGRAPHS BY

# JOHN NICHOLS

W · W · NORTON & COMPANY · NEW YORK · LONDON

Portions of the Introduction first appeared
in *American Photographer* magazine, August 1989.

The text of this book is composed in Bodoni Book,
with the display set in Antique Roman.
Composition by Zimmering, Zinn & Madison, Inc.
Printed and bound by Dai Nippon Printing Co. Ltd., Tokyo, Japan.

First Edition.

Library of Congress Cataloging in Publication Data

Nichols, John.
    The sky's the limit / by John Nichols.
        p.    cm.
    1. Photography—Landscapes. Essay, conservation, ecology. 2. Nichols, John. I. Title.
TR660.5.N495    1990
779'.36—dc20                                                                89–49093

ISBN 0-393-02865-8
ISBN 0-393-30717-4 (pbk)

W. W. Norton & Company, Inc., 500 Fifth Avenue, New York, N.Y. 10110
W. W. Norton & Company, Ltd., 37 Great Russell Street, London WC1B 3NU

1 2 3 4 5 6 7 8 9 0

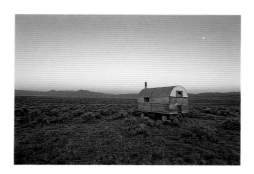

*For Juanita and the children: Luke, Colin, Tania, Dylan, Lance, and Heather.*

*For Andrés Martínez and the* viejitos *who hold the line.*

*For all those who struggle on behalf of this valley and the earth, including everyone involved with the Taos Nuclear Freeze, the Taos Valley Acequia Association, the Questa Concerned Citizens, the Nicaragua Construction Brigade, Amigos Bravos, Taos Amistad, the Taos Green Alliance, and all mayordomos and commissioners of the northern irrigation ditches.*

*For people of the mesa like Pacomio Mondragón, Delfino Valerio, and the Martínez family.*

*And with thanks to Bill Rusin for caring.*

# Introduction

ALMOST A DECADE AGO, when first I picked up a camera and headed for the mesa outside town, I had no specific vision in mind of either how to take a landscape picture or why. The places through which I meandered were all personal haunts, outdoor nooks and crannies that for years I had loved, worked in, adventured through. The wild places were almost as intimate to me as the territory of my inner being; familiar, logical, crazy, beautiful.

At first I had a hard time taking photographs. The act of pointing a camera made me too self-conscious about environment. I was used to being enveloped in a 360-degree panorama out there; photographs kept isolating sections of nature from the whole.

Then, one day, accompanied by an eighty-year-old friend, Andrés Martínez, I climbed a small three-summit mountain, Tres Orejas, which rises from the middle of the mesa. During the first decade of the twentieth century, Andrés herded sheep on the mesa. As we progressed, he pointed out landmarks, arroyos, old sheep camps—the haunts of his childhood. His stories imbued the land with a precious history. He remembered friends who had lived and died in that

sagebrush expanse. He plucked small medicinal herbs and called my attention to beetles, Hera moths, tarantula wasps. Without fear, he approached rattlesnakes and studied those guardian spirits of the mesa.

Once atop the small mountain, we could see for over a hundred miles in all directions: the landscape of Andrés's homeland and of his history. He detailed how the land had nurtured his people. He emphasized that as one of the last undisturbed areas of the valley, it must be protected. The first step was simply convincing people that the spare, wild territory was sacred. And it was at this moment I determined to share my friend's legacy of that land in hopes of keeping it vital, undisturbed, intact. I would learn how both to describe it and to defend it with a camera. I had my reasons why.

Although I had grown up influenced by the aesthetic graces, I seemed to have little preconceived notion of how a camera might contribute to political art. I found, when I first began to poke at the world with a lens, that I had little interest in literally transcribing the hills, mesas, mountains, and cloud formations of my world. Rather, I was trying to freeze the natural world at moments when it best expressed my inner emotions. Many pictures were one-dimensional, splashes of color like abstract paintings: Rothko, Motherwell, Kline. What interested me was not an easily recognized beauty, coherent to any casual observer, but rather a statement of my personal mood. Hence, my photographs began as a sort of diary of my daily inner existence.

I rarely thought of universal implications. And many of my landscapes weren't truly "photographs" per se. They were nearly empty,

devoid of structure. Vast numbers of them exhibited only slight grada-
tions of drab colors on the sagebrush mesa west of town. I loved bland,
empty skies. I gravitated toward a dearth of triggering formations. I
wanted no confusion.

My pictures were outwardly dull and, I imagine, pretty boring to
anybody except myself. None of that dramatic Yosemite waterfall stuff
for me; no majestic Grand Canyon vistas to stir Wagnerian hyperbole. I
sidestepped trees, forests, complications. I decided early on that aside
from using a tripod, I would avoid technology like the plague. No
filters, geegaws, gimcracks, or other mind-altering (image-altering)
toys. I am a man who cannot stand to view the world through sun-
glasses, even if my eyes are being blinded by snow. Altered states have
always given me the willies.

Plus, admittedly, I am a technology klutz. I flunked math four straight
years in high school. I have trouble patting my head and rubbing my
stomach at the same time. To make instant calculations in my brain while
futzing with lenses, apertures, different ASAs, and shutter speeds (as the
light changed every six seconds) was far too much for my poor head to
handle. So I wound up using only one film (Kodachrome 25), three Nikkor
lenses (20 mm, 35 mm, and an 80-200 zoom), and the simplest camera
with a reliable built-in meter I could find (a Nikon FE).

I took hundreds of pictures of the same unassuming subject matter:
mesa, clouds, sky, weather. I was recording emptiness, all the space
around me. Occasionally I focused on tiny rain puddles surrounded by
infinity. Close-ups almost never intrigued me. I recorded skimpy, nearly
invisible distant ridgelines of fuzzy mountain ranges completely dwarfed
by enormously incontroversial skies. The peacefulness inherent in the

monotony of open spaces became my holy grail. I did not know it then, but I understand it now: That spate of picture taking saved my life. I could unwind where my unwinding was allowed to unravel across the deserted plains forever.

Photography provided therapy, an escape, a liberation. The camera became both a statement of personal freedom and a yearning after that freedom. It was a simple way of letting off steam, of defining what is solid and unremarkable, of touching what endures.

Later I began to home in on things, places, a single piñon tree, the distinct shapeliness of Tres Orejas, that familiar three-crowned mountain. The mesa metamorphosed from being distant, inanimate, and ill defined into a place with character, culture, personality, every bit as alive and complex as my fellow human beings. Cleverly it started to manipulate my awareness of earthly conditions I had never noted quite so closely, or quite as intimately, before. The landscape and weather patterns familiar to (but heretofore taken for granted by) my everyday life acquired new privilege through a lens. They became the compass coordinates, from all vantage points around the valley in which I live, off which, at any given moment, at any particular spot, I could instantly measure—and understand—my whereabouts: my actual position and my psychic raison d'être.

All my life I had venerated the natural world, yet it was a camera, finally, that forced me to take it seriously at deeper levels. Nature ripened immeasurably, full of flaws and prestidigitation, when I began to inspect it and freeze it through a lens. It led me by the hand through miracles to which I had never paid attention.

I became as familiar with the changing patterns of cloud in the sky, the colors and moods of light, as I am with the volatile weathers of my heart.

Soon I could predict the shape and colors of a sunset long before they happened. Sounds corny, maybe, but we began to echo each other: the variations on my inner madness, and the turbulence, or lack of same, of the land and sky around my town.

All pictures in the following essay were taken on the mesa, most at three locations fairly close to each other. I have my special spots, and I return to them regularly. I never get bored. Eliot Porter once said: "I photograph the same old things over and over again. It's a little different each time. It's infinite. There isn't any limit. . . . You can't exhaust a subject."

I agree.

For several years during the early 1980s the place I visited most often was a small stock pond far from any trees or other "interesting" objects. Sometimes the pond held water—puddles not much larger than my kitchen table. On rare occasions it filled to the size of, say, half a baseball infield. But mostly it was a mere dusty declivity surrounded by sage-brush, thoroughly useless.

Yet I wrote an entire book about the three hundred square yards of mesa which held that seasonal puddle. I have rarely experienced a location so rich in magic. That tank gave rise to an enormous amount of life. Often, in the autumn, I sat quietly at the edge of the water while migrating ducks, avocets, phalaropes, and sanderlings came by. If I remained very still, the birds paid no attention. Sandpipers walked up to my feet and hunted for bugs in the treads of my sneakers. Though I was totally exposed, I never moved or made any noise. Toward evening, when the winds died, the silence out there was delightful and profound.

A mile from the stock pond is a crack in the mesa, the Rio Grande

Gorge. At many points it is less than a quarter mile wide, and it runs to eight hundred feet in depth. At a certain rock outcropping I like to sit and watch the buzzards and ravens soaring below. Inevitably I am surrounded by swallows, bats, and nighthawks. Ever-present are the haunting and melodious diving cries of canyon wrens.

Ten miles east of the rock overlook lies my hometown. It rests at the base of the Sangre de Cristo Mountains, whose peaks rise to thirteen thousand feet. From my gorge rim hangout, however, the range has a diminished look. The mountains are full of deer, bear, elk, wild turkey, grouse, and mountain lion. But from my perch above the river those hills seem perfectly harmless, easygoing, very remote.

My third favorite locale is closer to home, south of town, a ten-minute drive from the house. Often at dusk my wife, Juanita, and I (and our dog, Mangas) go there to jog. Or we simply walk and talk. Again, there's only sagebrush for miles in all directions, and a few dirt roads, but rarely other people.

We park at the same location every night, and from that station I have taken many pictures. To the southeast is a group of mountains including Picuris Peak. To the north lies the town, and above it, the highest point in the state at 13,161 feet. Westward, across the gorge, are various bumps of no particular dramatic interest to the casual observer, although to me they are familiar and sacred. One is Tres Orejas. Five miles north a smaller hill is called, simply, Cerro, which means "hill." Beyond, two insignificant pyramids are Huerfano and Dormilón. Way in the distance is a square-topped mesa mountain, Pedernal. Far to the south stretches the hazy silhouette of the Jemez chain.

In June the sun sets directly behind Tres Orejas. By December it

disappears way down south. From our jogging spot, on almost any given date, I know exactly where the sun will set. And I am comforted by this knowledge, which seems to create an intimacy with rhythms of space and time.

Events of great import rarely happen on the mesa. Life is prosaic on that sagebrush plain. Nighthawks twitter above, booming; occasionally Juanita and I jog past rattlesnakes sunning on the dirt road; at dusk coyotes usually raise a racket, then fall silent; pretty soon the stars come out; eventually we go home.

Often the wind is bitter enough to make the mesa a delightfully hostile place. But when all weather-induced motion suspends itself, there exists a moment of hushed and quiet repose unparalleled on earth. Because there is nowhere to hide, I am totally exposed and very fragile. Yet through that vulnerability I feel closely linked to the universe, to all of life itself.

I do not voyage comfortably, any longer, in areas of the country where space fails to extend in all directions for at least a hundred miles. I get crazy if horizons are interrupted by buildings, forests, hills. I need to see ahead, behind, all around me. I cannot abide pollution. I am not charmed by a red photochemical sunset beyond the majestic silhouetted spires of Manhattan. I tend toward prairies everlasting, especially where there's too much wind, plenty of snow, and a panavision sky. Anything less, and who can breathe?

Inevitably a landscape photography, which began as a method of elucidating my own temperatures, soon developed into a way of taking the pulse of the biosphere in which I live. My well-being depends upon the health of that biosphere. As Ernest Hemingway once used to take his

blood pressure daily, so did my pictures begin to serve a similar purpose. Nothing so much as a careful attention paid to the varieties of light captured within an autumn afternoon on the mesa can shed knowledge upon the poisons, or lack of same, in the spectator's lungs. Pictures soon became my way of keeping score. Landscape, the intensity of light and weather, the clarity of ozone, the quality of wind—they all added up to the blood pressure of an environment on which I am totally dependent.

Of course, all of us have always been held captive by the health of the biological capital upon which we totally depend for survival. But few of us are truly aware of it. Few of us admit how integral every living thing is to our own aliveness. Blithely, with no malice aforethought, we help to kill everything that sustains us. To act otherwise would be an enormous inconvenience. It helps not to inspect too closely the "dehumanized" planet which pays for our sins in spades. But it is impossible, when we cast an eye about for pictures, not to see clearly what exists.

It evolved, then, that I began to show my simple pictures as a way of saying to others, "Wake up and fly right, before the earth is gone." Many of my photos, a matter of daily habit to me, were, for most of the planet's citizens, already wishful thinking. In much of our world my kind of mesa is memory, already extinct. I often consider that I live in a sort of Galápagos valley; the scenes my camera captures are iguanas, turtles, tiny finches... all of them perched on the brink.

When you start to care about a place, fear rises. I gave a few slide shows in defense of the mesa's unmolested spaces. I urged people to look, be moved, and recognize—in these colors, shapes, and forms—something innate to their own well-being worth fighting for. And shortly I concluded that no picture of the natural beauties which yet remain exists

independent of the struggle to save it. At this late date, landscape cannot be a simple entertainment. The earth (and how we perceive it) have forever lost their innocence.

When a human being—woman, child, man—is moved to record on film (or on canvas or in a novel) some piece of earth that momentarily shines enough to stir their imaginations, theirs is an act of both aesthetic and political conscience. It is a way to forge within the cultural memory of all races the possibilities for a continuing evolution, an enduring future. The Sierra Club understood this long ago, and thanks to it, I first became enthralled by simple pictures of landscapes taken by artists like Eliot Porter, Philip Hyde, and Edward Weston. Their work was accompanied by the no-nonsense, ofttimes elegaic words of Ed Abbey, Robinson Jeffers, Willa Cather, Thoreau . . . and a Navajo medicine man advising people to "go in beauty."

Today all landscape photography is an act of conscience and commitment. Each photograph is a voice raised in protest, as well as a hosanna for the planet. More than 70 percent of us in this country now live in urban areas and have little congress with the biological capital upon which our lives depend. Pictures of this sweet earth, then, are important to everyone's education. They have become part of a language that must be learned if the future is to be hopeful. Any photograph of unsullied terrain contains within it a message to halt population growth, redistribute wealth, labor hard to solve social problems, ban pesticides and other toxic wastes, save the dying whales. There is an urgency to even the most peaceful and bucolic landscape impossible to deny. The invisible underside of the iceberg in any portrait of the earth is always the strip-mining bulldozers, just out of frame, gearing up to plunder.

Sounds like a burden, but I think not. Rather, I believe that when any photographer elects to interpret the fascination of a natural moment, what he or she does is reaffirm the collective conscience of us all.

Pictures of the natural world have become poignant in a manner almost unbearable at times. They remind us of the building tragedy. But also, I hope, they encourage us to take sides, to take part in the revolution that must happen to change the downward slide. Ultimately it's going to be a traumatic trade-off: my automobile to save that mountain; your VCR to save my lungs; their flush toilet to save that river of trout. Almost within twenty-four hours of the terrible Alaska oil spill in 1989 I began to read newspaper and magazine articles featuring "before" and "after" photographs: the Beauty, the Disaster. The process is repeated, daily, across all natural environments.

Where I live there still exist cultures that praise the land and try to exist in harmony with it. They are living examples of the "before" and therefore important teachers for our return, in the future, to the more viable equilibriums of the past. The growing body, worldwide, of photographic landscapes extends a similar blessing. Increasingly the pictures chart a diminishing world, attempting, by their beauty, to convince us that the planet is worth saving, that we ourselves should continue longer than seems in store. Our lives depend on that beauty, which, after all, is only a reflection of health, of nature—and humanity—in balance and determined to remain that way.

The following pictures are mostly of air: sky, clouds, weather. They were taken at my hallowed places on the mesa. They are the "before" photographs of a small valley striving to become an "after." As a person who suffers from asthma and is prone to numerous allergies—particularly those induced by human-made substances—I am extremely aware of air

as an invisible carcinogenic soup. I am easily sickened by its poisons. I am more "chemically sensitive" than most people (although the rest of humanity seems to be catching up fast). Even when the atmosphere looks beautiful, I know that it's killing me. I often say to others that people in my boat are like the canaries underground miners used to carry to warn of impending disasters. I have grown to be both suspicious and afraid of all the air on earth.

At first, it may seem that there is little correlation between the following text and photographs. Readers may ask: Why this exercise in antonyms? Yet, as I mentioned earlier, I cannot look at a lovely scene without being aware of the bulldozers just out of frame, waiting to plunder. There is no such thing, anymore, as an apolitical landscape photograph. All environment is threatened; all air is poisoned. Hence, the more unspoiled a moment appears, the more intensely I fear its pending destruction. To sustain the mesa, citizens of our town must refuse to pave the roads, build garbage dumps, bulldoze fragile terrain. Our community must protest poaching and derail plans to run mammoth electrical lines up through the center of the sagebrush plain. Because we pollute the mesa air with dust, carbon monoxide, woodsmoke, trash burning, and grass fires, we must change our ways of living if our children are to inhabit a livable environment. And because the rest of our pollution comes from Albuquerque, Four Corners power plants, and Chicago and Dallas and Los Angeles, we must admit that our local battles require a universal mind-set.

At times, when the West was burning in the summer of 1988, visibility here dropped to less than ten miles, thanks to a pall of Yellowstone smoke hanging over the valley. Obviously, then, any struggle on behalf of this insignificant mesa requires a universal commitment.

Even as the mesa's tranquillity uplifts my spirits, it also increases my

anguish. At its most peaceful, the panoramic land sets my mind racing through the world situation, which I know can bring down the mesa in a minute. I cannot bear the idea of losing this place. I also realize that no one has a right to be lulled by this beauty. During any given spectacular sunset, my tax dollars are helping to oppress Guatemala and El Salvador...and air molecules I respire into my lungs are hatching cancer cells.

The following text, then, is often what goes on in my mind while I am a participant in quiet natural moments.

Beyond that, who knows? I think of Monet, who returned to the same spot, endlessly, and always found it both reassuring and original. I do the same. I keep in mind that the implications are infinite. No photograph is an island, apart from the main...and every print is a bell that tolls for thee.

I am thankful for Ansel Adams and Eliot Porter and Laura Gilpin, for Philip Hyde and Ray McSavaney and Joel Meyerowitz's *A Summer's Day*, for William Clift and Jay Dusard and Jim Bones, and for Terry Evan's lovely *Images of Ground and Sky*. Their work, and that of many others, has become the foundation of a case that needs to be made for Planet Earth. Landscapes have become the conscience of our survival, the measuring devices of how well or how badly we are doing. They are the work of organizers, also prophets. There is a religious element in all of them, in that they offer hope.

To consider as anything less a photograph of that exquisite place, or of this tree, or of those rocks and clouds, is to miss the point completely.

# THE SKY'S
# THE LIMIT

Today it is generally feared (if not universally acknowledged) that the Greenhouse Effect has begun. The six hottest years in the past century have been 1989, 1988, 1987, 1983, 1981, and 1980. The earth is beginning to overheat; the atmosphere is polluted; acid rain threatens our rivers, lakes, and oceans. Various holes in the ozone are widening. Population continues to expand around the globe, and starvation is a fact of life in the Sahel, Bangladesh, Haiti, and Bolivia. Garbage scows from large United States cities ply the high seas, searching for third world countries willing to absorb their toxic wastes, which, though fabricated in North America, cannot legally be disposed of here. In the summer of 1988 East Coast beaches were temporarily closed because of pollutants, which included syringes of human blood infected by AIDS.

Yet, when I first walk out upon the mesa in the evening, it's difficult to acknowledge the menace to our planet. For the landscape around me seems healthy, at ease, serene. Nevertheless, I know the air I breathe is full of poisons; Chernobyl radiation actually showed up in nearby Santa Fe. And lakes in the mountains above my home are beginning to show signs of the acidity which has already killed so many bodies of water back east, in Europe, throughout Sweden. A dull (and venomous) haze carried over from electricity-generating plants farther west of here often darkens the valley. Plus woodsmoke, carbon monoxide, pesticide remnants, and plain old dust are prolific in this atmosphere.

Still, on any given day I can see for a hundred miles.

So far, in this, my home territory, the worst portents of extinction are invisible.

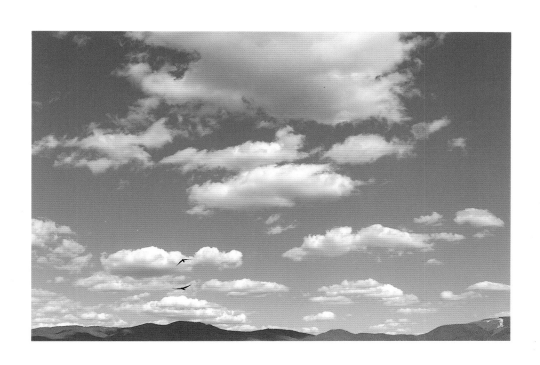

What soon becomes abundantly clear, however, is that the fragile domain of this valley is about to self-destruct. For it's a simple axiom that nothing exists disconnected from everywhere else on earth. No portion of the ecosystem can function apart from the main. "Whenever we try to pick out anything by itself," said John Muir, "we find it connected to everything else in the universe."

Thus, winds carry the oxygen forged in the jungles of Brazil to be breathed by penguins sunning themselves on Antarctic ice floes. Water evaporating off the Great Lakes descends as malevolent rain upon the green fields of Ireland. When spring plowing begins in China, dust clouds soon blanket the skies over Hawaii. A tuna fish captured near Hawaii winds up in the sandwich I eat for lunch (and a handful of my brain cells are crippled by the mercury deposited in that fish by a chemical factory in Japan).

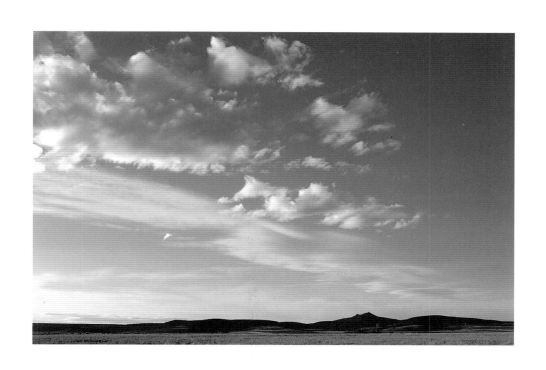

In the November 1987 *Discover* magazine is an article called "Toxic Wind" by Michael H. Brown (the reporter who exposed chemical seepage at Love Canal).

The article starts when furans and dioxins—"two of industry's supreme poisons"—are discovered in the forest mud of a virgin lake—Siskiwit— on pristine Isle Royale, in northern Lake Superior. How did these toxins get there? They traveled on the air.

Brown calls the oxygen we breathe a chemical cocktail. "Furans or dioxins, for example—both by-products of incomplete burning—have been detected in seals from Sweden, snapping turtles from the Hudson River, and cow's milk from Michigan."

Toxaphene, used to kill boll weevils in Mississippi, has been found in Antarctic codfish and in Canadian polar bears.

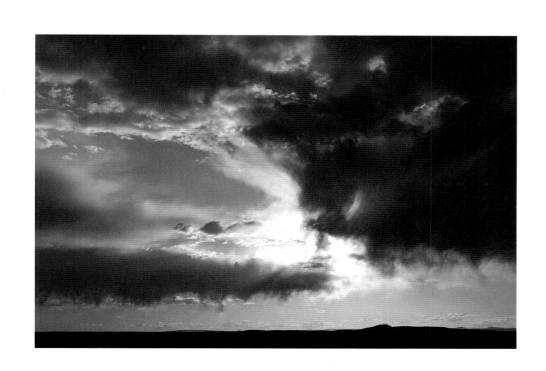

Michael Brown explains that this is a small planet: Poisons from Chernobyl needed only eleven days to reach the United States. Every year, arriving from all directions, approximately thirty thousand pounds of poisonous polycyclic aromatic hydrocarbons fall from the air into the Great Lakes, "along with thousands of pounds of a carcinogenic insecticide called benzene hexachloride."

According to a recent Environmental Protection Agency (EPA) report (which excluded automobile emissions and toxic waste dumps), U.S. industries pump 2.4 billion pounds of toxic chemicals into the air per annum.

The average person drinks about two liters of poisonous water a day. But, says Brown, "We *breathe* ten thousand to twenty thousand liters of air a day." Each breath contains ten billion trillion air molecules. Dioxin concentrates in the atmosphere of as little as one part per quadrillion still means we're sucking in "more than a million molecules of dioxin" with every gasp.

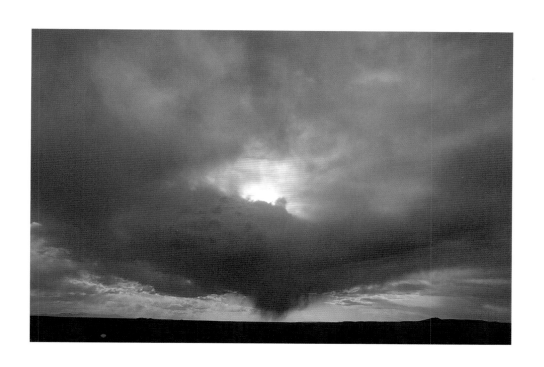

Sometimes, glancing up at all that invisible trash, I get a trifle frenetic and think, "Oh, dear, we've poisoned the waters and leveled the forests and eroded away the topsoil, and now the air is difficult to breathe. And if we run out of air, it's all over. The sky is very beautiful today, but the sky is the limit of our resources. There's nothing else to wreck, once all the air is gone."

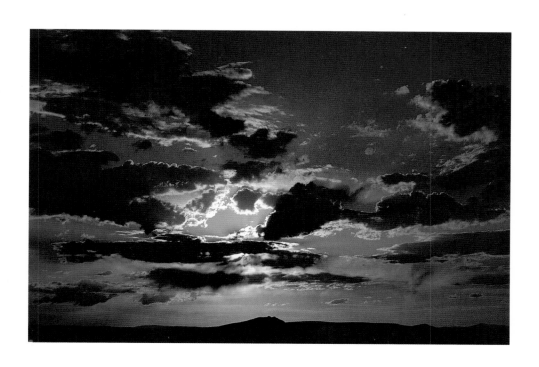

The good news is: We still have air to breathe.

The bad news is: We may not have it much longer.

Today there is five times more chlorine in our atmosphere than there was in 1950.

And two-thirds of the ozone over springtime Antarctica isn't *there* anymore.

One pollutant—the chlorofluorocarbons (CFCs) found in Freon, refrigerators, insulating foams, auto air conditioners, and plastics—is destroying the ozone layer, exposing the earth to intense ultraviolet radiation from the sun. This doesn't just produce skin cancer in people; it destroys things like leaves and plankton which fabricate the air we breathe and nourish the basic food chains of life.

Carl Sagan says that by destroying the ozone, "We are tugging at a planet-wide biological tapestry and do not know whether one thread only will come out in our hands, or whether the whole tapestry will unravel before us."

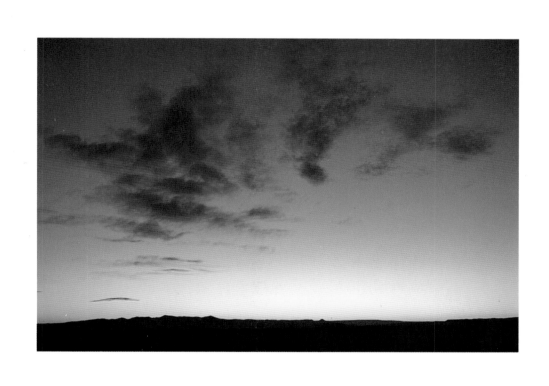

If we are to believe the ecological doomsayers (and I do), then human evolution has already arrived at the brink of extinction. Clearly, an environmental disaster, of the intensity that destroyed the upper New York State community of Love Canal (or Times Beach in Missouri), awaits the entire planet.

According to the World Wildlife Fund, a forest the size of New York State is lost to the planet every year. In but a few years of concentrated exploitation, over 20 percent of the Amazon jungle has been rubbed out; a million Brazilian trees are toppled every twenty-four hours. Worldwide, approximately twenty-three billion tons of topsoil are lost to erosion yearly. In Nepal more than half the entire forest reserves have been annihilated in the past two decades.

When Columbus spied Haiti in 1492, the land was almost completely forested. Today only 2 percent of that impoverished country has trees.

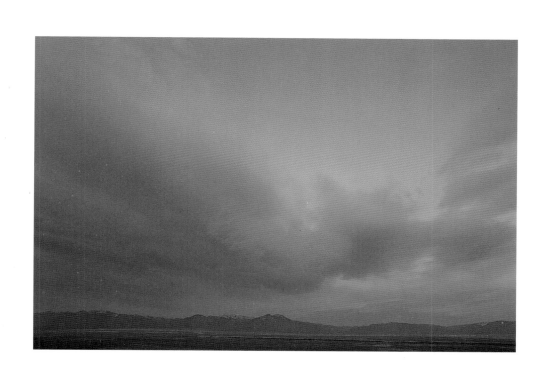

It is predicted that in my lifetime (I'm forty-nine) animals such as lions, tigers, and mountain gorillas will disappear except for those on the life-support systems of zoos.

If the Amazon forest continues to be destroyed at the current rate, 66 percent of its plant species and 70 percent of its bird species will be lost by the year 2000.

Since the creation of national parks in the United States less than a hundred years ago, those parks have seen between one-quarter and one-third of their original mammal species go extinct.

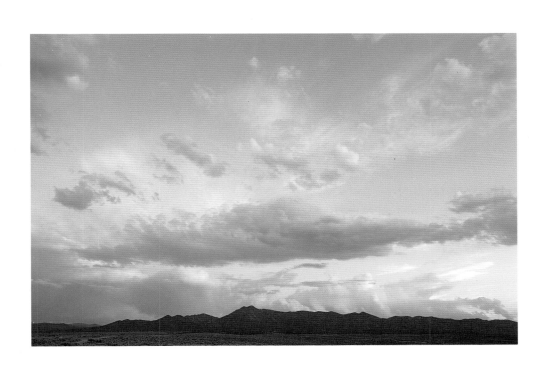

Of the approximately thirty thousand varieties and species of vascular plants in the United States, three thousand are close to extinction.

In Texas, construction threatens the last few hundred pairs of black-capped vireos. And near Albany, New York, it looks as if bulldozers are going to wipe out one of the last known colonies of tiny (one-inch wingspan) Karner blue butterflies.

Chimpanzees are already a "threatened" species; their use in AIDS research may shortly put them on the "endangered" list.

The dusky seaside sparrow of Florida was declared officially extinct on June 16, 1989.

According to James Udall in the July/August 1989 *Sierra* magazine, "The specter of global warming puts everything conservationists thought they had saved at risk again. We're back to square one."

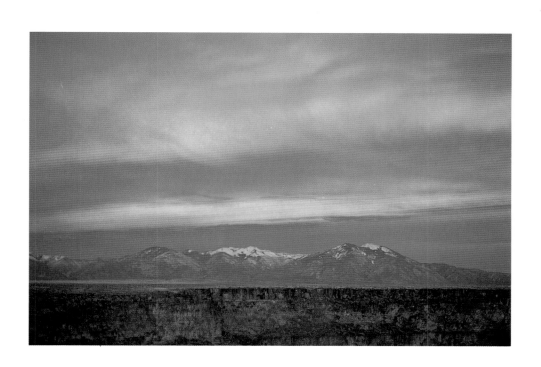

Some forecasters give the earth itself only until about 2050, unless radical changes are made. I.e., we had better clean up the air, purify the waters, replenish the topsoil, reforest the globe, and solve sociopolitical problems caused by the unequal distribution of wealth among human beings, or else it's curtains for sure—Payday at Eternity Junction.

"No generation in the past has faced the prospect of mass extinction within its lifetime," says environmental consultant Norman Myers. "The problem has never existed before. No generation in the future will ever face a similar challenge; if this present generation fails to get to grips with the task, the damage will have been done and there will be no 'second try.'"

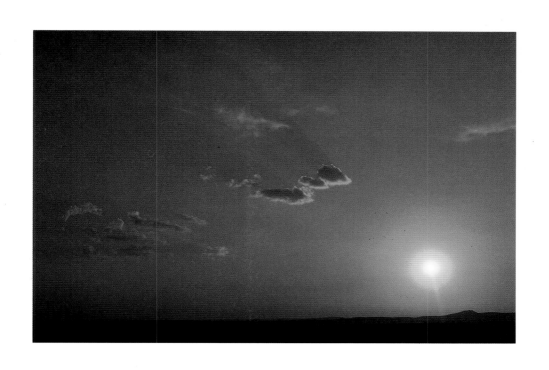

Closer to home, in the nearby Sangre de Cristo Mountains, clear-cutting of trees in the early part of this century denuded many hills. This meant winter snowpack was more exposed to spring sunshine. The result was a faster runoff of snowmelt, which has caused water shortages later in the peak summer irrigation season ever since. And agriculture has declined in the valley.

The bare hillsides, and the logging roads leading to them, unleashed erosion which deposited large amounts of natural mercury in the small creeks flowing down to town. The trout populations of these creeks became infested with enough mercury to make them technically unsafe to eat.

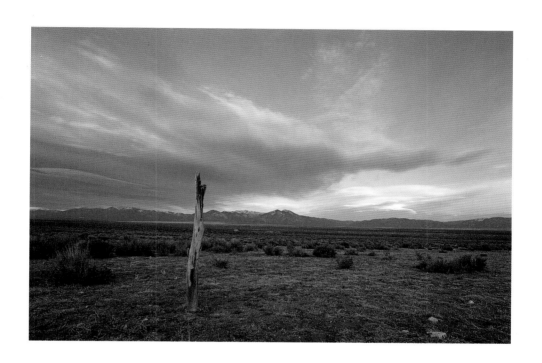

To meet the timber and housing industries' demands for lumber, the government long controlled forest fires in the local area. This practice led to an overdensity of trees, which facilitated the spread of spruce budworm. Massive die-offs of the trees occurred. Today large tracts of valuable timber are ruined for the aforementioned industries by that pest. Pesticides sprayed on the budworm population have added to the pollution of water supplies. Hence, my garden, which depends on irrigation water flowing from the diseased mountains, will never be a truly organic venture. Perhaps in me is already growing a cancer derived from eating my own carrots that were irrigated by water poisoned on behalf of some midwestern prefab housing developer.

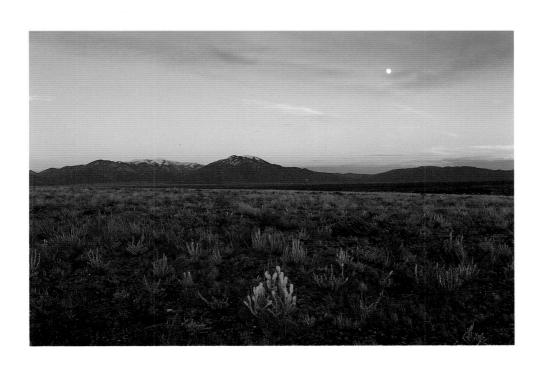

In the sweltering summer of 1988 everyday citizens, scientists, and the news media seriously confronted the Greenhouse Effect. Power companies across the nation reported record or near-record use of electricity as Americans sought relief from the heat with their air conditioners. In order to meet their demands, more fuel than ever had to be consumed in order to create the power behind all those air conditioners. Obviously, this caused an upsurge in the pollution which helped to create the heat wave in the first place.

Pollution is caused by our demand for energy. The most publicized U.S. pollution of 1989 was the Alaskan oil spill. To put the size of that disaster in Lower 48 perspective, if the *Exxon Valdez* had gone aground off Cape Cod, the oil would have devastated most of the eastern seaboard (including Long Island Sound) between Boston and North Carolina's Outer Banks.

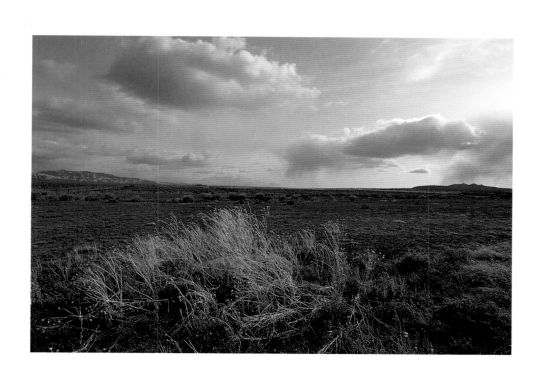

Most people, when flicking on a light switch, do not reflect on the implications of electricity. But the juice doesn't come for nothing, and you can't buy your way out of a guilty verdict simply by paying your monthly bill.

When I flip that switch, a mining company bulldozer on Black Mesa in Arizona starts up, burning gallons of irreplaceable fossil fuel as it strip-mines another ten acres of soft coal, displacing many desert creatures, plus a few Hopi Indians. The Indians must be relocated at taxpayer's expense, to cheap government housing (where, bereft of their land and traditional roots, they may fall into costly patterns of depression, alcoholism, welfare dependency, and other sorrows which are the stuff of cultural genocide).

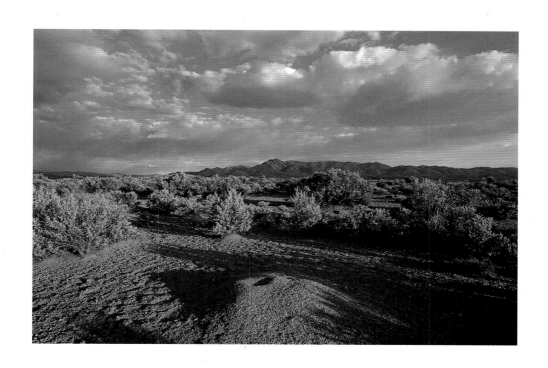

Water, for use in coal slurry lines, is then diverted from rivers near Black Mesa, lowering their levels, killing more fish, and further endangering the aquatic life cycles of everything from goldeneye ducks to beavers.

The slurry lines carry the coal to an electricity-generating plant in the Four Corners area. When the coal is fired up to turn the vast electricity-generating turbines, pollution gushes into the air. Prevailing currents waft that pollution a few hundred miles east to Taos, where clouds unleash their poison rain upon our lakes and rivers...and into my garden.

There is a direct connection between my demand for electric lighting, the destruction of Hopi culture, and that cancerous carrot in my "organic" garden.

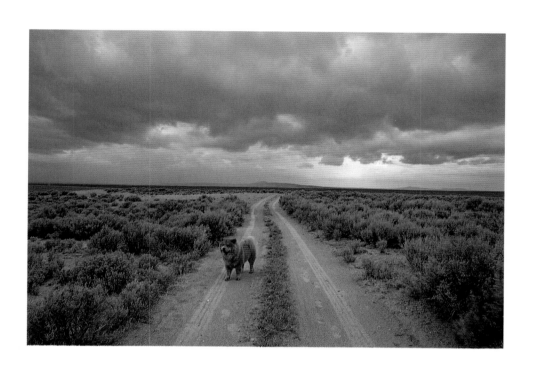

My friends Katherine and Peter Montague published a book called *No World Without End* in 1976. In it they state: "To maintain the average person's style of life in America, we now extract from the earth (and then process) 40,000 pounds of new mineral materials for each person each year, and, as Harrison Brown said in *Scientific American*, 'This quantity seems certain to increase considerably in the years ahead.' The average American in 1970 required seven times the world average mineral usage per capita, and 100 times the average per capita energy used in the poor countries. The U.S. population—less than 6 percent of the world total—uses one-third of total world energy production each year and one-third of all the raw materials mined from the earth. By 1980 U.S. population will represent an even smaller percentage of world total, but we will be using perhaps 50 percent of the entire world raw-material supply."

They were correct. It has come to pass.

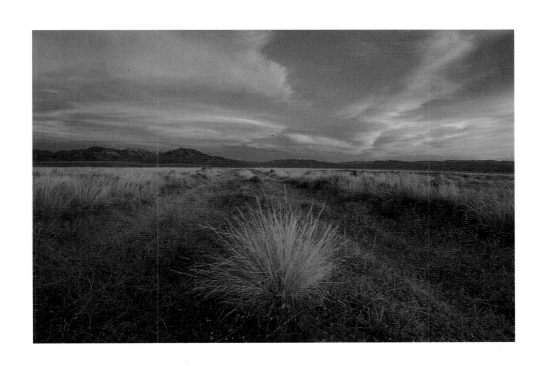

Worst of all, for the world and its resources, is the fact that we transform a stunning amount of those raw materials into garbage.

How much garbage? Would you believe 4.5 pounds per person a day? Almost 28 pounds a person a week? And 1,547 pounds yearly for *every* citizen in America? Or 157.7 million tons of it for the entire country per annum?

Included in these figures is the fact that we generate 70 percent of the entire planet's solid waste annually.

In Rome, per day, it's 1.5 pounds per person.

The Japanese recycle 50 percent of their wastes. We recycle only 10 percent.

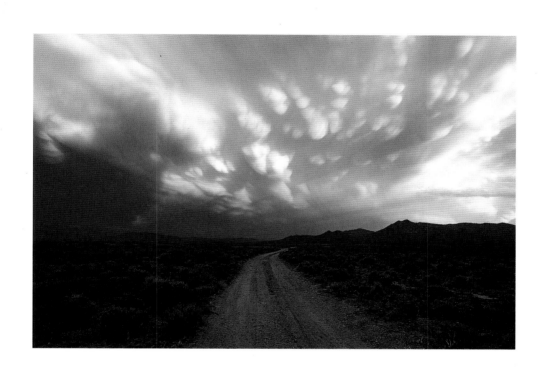

In the United States 20 percent of all garbage is grass clippings and autumn leaves. Also, 10 percent of what we spend on food and drink is for packaging that we simply toss away—and *it* amounts to 50 percent of all household garbage.

In Japan 95 percent of the beer and soft-drink bottles are used twenty times. In Holland 95 percent of soft-drink containers are returned by consumers.

In Nigeria you can get shot for trafficking in toxic wastes.

In America we throw it *all* away.

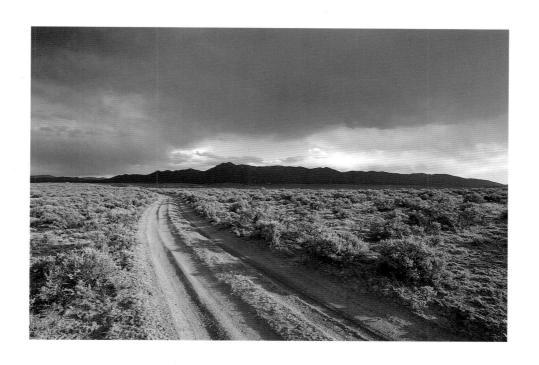

In the early days of our nation we developed a plantation mentality. Cotton growers would plant the same five thousand acres year in, year out, until the soil was exhausted. Then, because land was plentiful, they would simply move over to virgin earth, work that repeatedly until it was drained of nutrients, and move on again. And our national economic philosophy of Planned Obsolescence and Conspicuous Consumption grew up around a single crucial important idea: that resources are basically infinite.

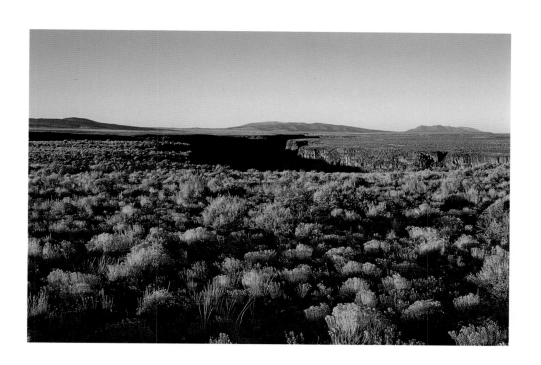

Today two of our most important economic tenets are still Planned Obsolescence and Conspicuous Consumption. Things in demand are built to fall apart; resources are meant to be wasted rather than conserved. We are taught to consume merely for the sake of consumption, and we are brainwashed to believe that in this consumption lies not only great profit but also our spiritual fulfillment.

Hence, we destroy the earth for countless varieties of banal amusements having nothing to do with the necessities of survival. It would almost seem that our *entertainment* is the destruction of environment.

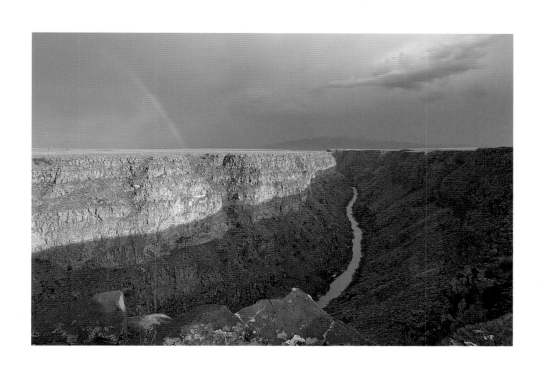

*Earth*, by Anne and Paul Ehrlich, provides a lucid macroscopic overview of the planet and its current dilemmas.

At one point the authors reveal that the 1986 per capita income of the United States was $14,000; of the United Kingdom, $9,000; and of India, $260. "Assuming that the impact per unit of consumption was the same in all three nations, the birth of an American baby would represent more than 50 times, and that of a British baby nearly 35 times, as great a threat to global resources and environmental systems as that of an Indian baby. A similar calculation makes a Swiss baby more than 125 times as large a contributor to the degradation of Earth's resources and environment as one born in Bangladesh."

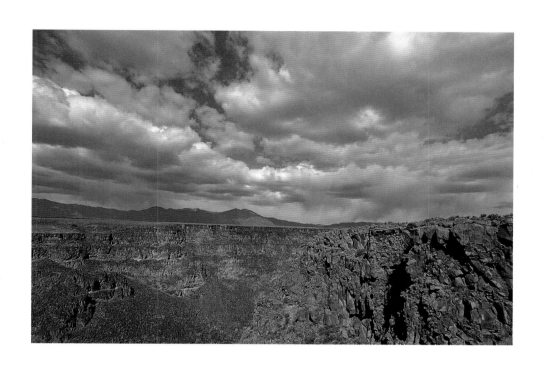

The Ehrlichs reveal that tiny Switzerland causes eight times the environmental devastation as Bangladesh, even though Bangladesh has sixteen times the population. "Similarly, India's total impact is less than twice that of Switzerland, although there are more than 100 times as many Indians as Swiss. And Japan has four times the impact of China, even though its population is only one-ninth as large.

"By this simplified calculation, the United States is the world champion, having 17 times the impact of India (with a third as many people) and 11 times the impact of China (with less than a quarter of the population). The impact of the United States is even twice that of the Soviet Union, its nearest national competitor in wrecking the planet, in spite of Russia's slightly larger population and almost equally massive industrial plant."

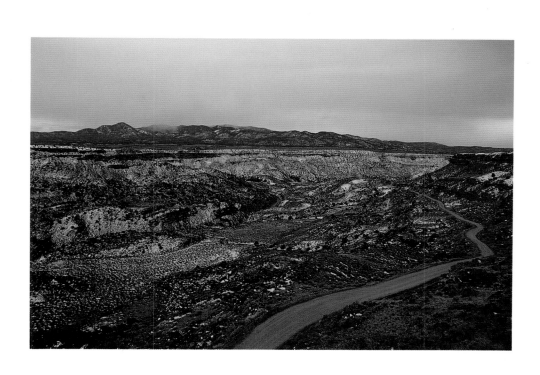

The Ehrlichs conclude: "So it is the rich who disproportionately threaten the capacity of Earth to support humanity and all the other organisms that live on the only known habitable planet. It is they who are extracting and dispersing non-renewable resources and consuming fossil fuels as if there were no tomorrow while spewing pollutants into the atmosphere, rivers and oceans. They are the principal spenders of humanity's capital."

Carbon dioxide ($CO_2$), created by burning fossil fuels, is a principal culprit in forging the Greenhouse Effect. Although today we Americans constitute only 5 percent of the world population, we create 23 percent of the world's $CO_2$. That comes out, yearly, to 18.4 tons for each of us.

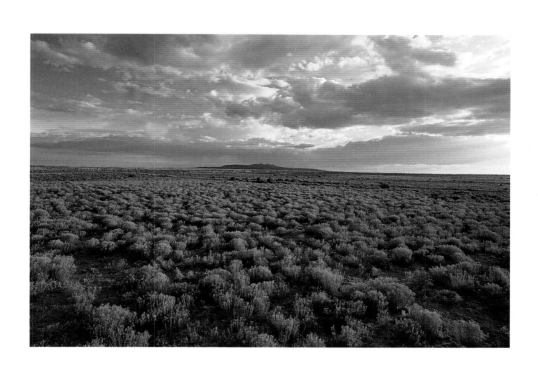

In his book *The Closing Circle*, Barry Commoner also presents a macroscopic overview of the damage we have done to the planet through carbon monoxide emissions, deforestation, chemical fertilizers, manufacturing pollutants, detergents, plastics, and so forth. He explains that "a high rate of profit is associated with practices that are particularly stressful toward the environment." He concludes that profit taking by causing pollution or terminal destruction of resources "is irrational because pollution degrades the quality of the environment on which the future success of even the most voracious capitalist enterprise depends." As one of the more obvious examples of this contradiction within the capitalist economy, he cites the whaling industry, which has all but driven itself out of business "by killing whales so fast as to insure that they will soon become extinct."

Ed Abbey put it another way when he growled, "Growth for the sake of growth is the ideology of the cancer cell."

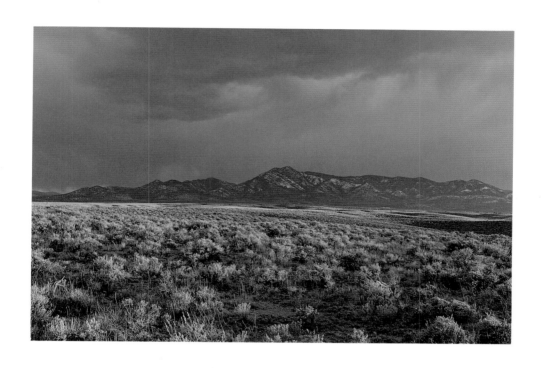

Philosophers like John Stuart Mill understood the problem but felt capitalism could achieve a balanced no-growth state. Instead, our economic system has conformed more to the Marxist understanding that capitalism is *defined* by frantic growth—the expand or expire syndrome.

If, according to Commoner, "it is concluded that the private enterprise system *must* continue to grow, while its ecological base will not tolerate unlimited exploitation, then there is a serious incompatibility between the two."

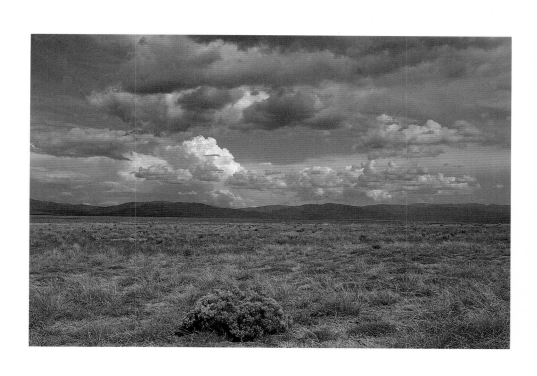

Perhaps we should clarify some terms. "Ecosystem" doesn't just mean earth, air, water, plants; it means human beings and human community as well. And "biological capital" isn't merely atmosphere, oceans, and redwoods; it includes people, their energy, their life-styles and culture, their hopes and dreams.

A rapacious industrial world in search of profits destroys these people with the same indifferent brutality it applies to farmlands, rivers, and the air we breathe.

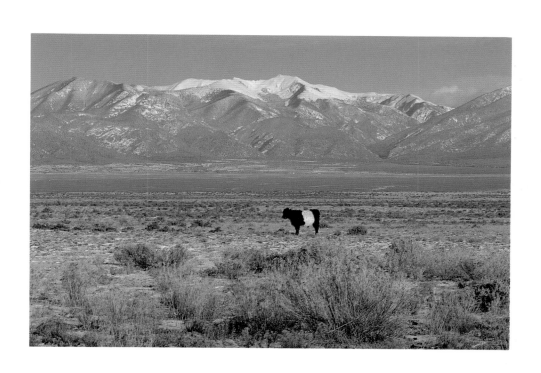

In 1988 the U.S. General Accounting Office issued a report stating that sweatshops continue to thrive in the United States. Worst offenders are the restaurant, apparel-manufacturing, and meat-processing industries, where a majority of the workers are Hispanic and Asian.

According to the report, the reasons for multiple labor law violations are "similar to those that existed in the Nineteenth Century: a large immigrant work force and low profit margins in labor-intensive industries."

Unfortunately, according to the report, when industries violate wage and child labor, safety and health laws, they receive only a slap on the wrist. After all, the business of America is business.

President Woodrow Wilson once said, "We are all caught up in an economic system which is heartless."

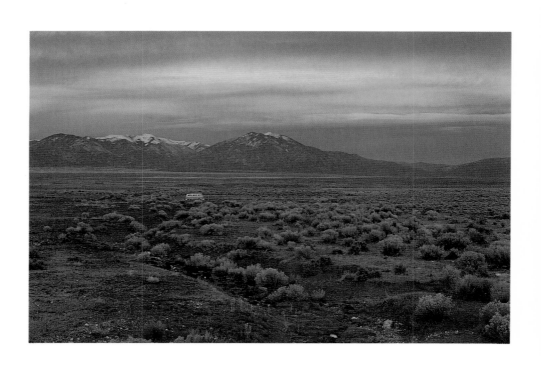

In his book *Open Veins of Latin America* the Uruguayan writer Eduardo Galeano describes the effect of our system upon his people:

"For those who see history as a competition, Latin America's backwardness and poverty are merely the result of its failure. We lost; others won. But the winners happen to have won thanks to our losing: the history of Latin America's underdevelopment is, as someone has said, an integral part of the history of world capitalism's development. *Our defeat was always implicit in the victory of others; our wealth has always generated our poverty by nourishing the prosperity of others—the empires and their native overseers. In the colonial and neocolonial alchemy, gold changes into scrap metal and food into poison*. Potosí, Zacatecas, and Ouro Prêto became desolate warrens of deep, empty tunnels from which the precious metals had been taken; ruin was the fate of Chile's nitrate pampas and of Amazonia's rubber forests. Northeast Brazil's sugar and Argentina's quebracho belts, and communities around oil-rich Lake Maracaibo, have become painfully aware of the mortality of wealth which nature bestows and imperialism appropriates. The rain that irrigates the centers of imperialist power drowns the vast suburbs of the system."

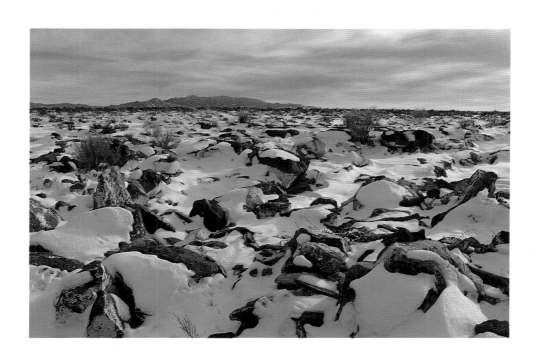

To put the preceding in perspective:

A basic understanding I have of the world is that many of our freedoms and much of our opulence in the United States are purchased with the oppression of other landscapes, other environments, and other people. That is a fact I cannot overlook, even out on the mesa.

In an essay entitled "Almost Thirty," John Reed, author of *Ten Days That Shook the World*, writes: "All I know is that my happiness is built on the misery of other people, that I eat because others go hungry, that I am clothed when other people go almost naked through the frozen cities in winter; and that fact poisons me, disturbs my serenity, makes me write propaganda when I would rather play."

Bertolt Brecht had a similar problem: "They tell me eat and drink, be glad you have it. But how can I eat and drink when my food is snatched from the hungry and my glass of water belongs to the thirsty?"

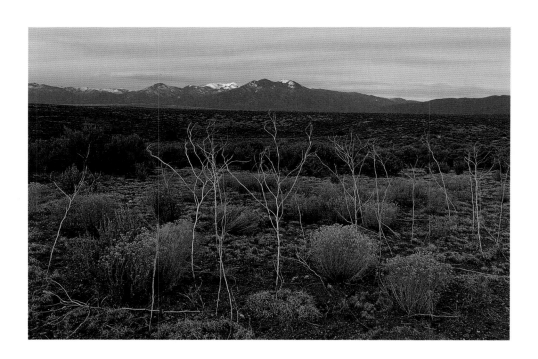

It's all economics, the struggle for who gets the pie. Orangutangs, Biafrans, giant sequoias, and impoverished Brazilians are interchangeably sacrificed so that the rich may dine on caviar or so that the middle class may watch Monday Night Football in an air-conditioned rec room. If somebody rocks the boat, there's always the menace of nuclear war to keep the uppities in their places.

Of course, nuclear war, being the ultimate threat to the environment, is unthinkable.

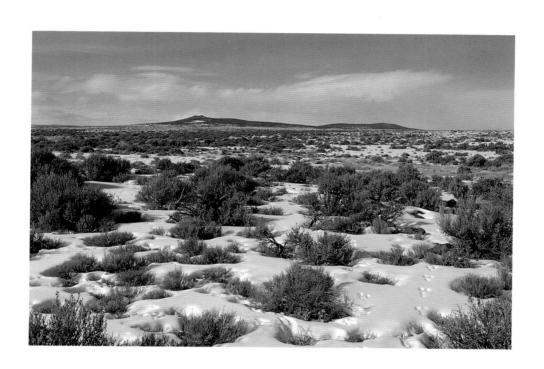

Or is it?

In his book *On Thermonuclear War,* Herman Kahn says, "War is a terrible thing; but so is peace." He proceeds to rationalize nuclear war by intimating that its risks are not much greater than the risks workers are already subjected to in our carcinogenic industrial society. It would not be a "total catastrophe" if twenty million nuclear war survivors lost ten or fifteen years off their life expectancies, because after all, even in peacetime, we Americans accept fifty thousand automobile deaths a year, plus many more injuries, not to mention the negative costs in real dollars (and in anguish) that result from this legalized mayhem. The rate of genetic hazards already proliferating in our technological world would not be significantly increased by a nuclear war, Kahn believes. The vast array of respiratory diseases, cancers, and nervous disorders caused by our polluted environment are already as devastating as anything that might result from the fallout of a nuclear exchange.

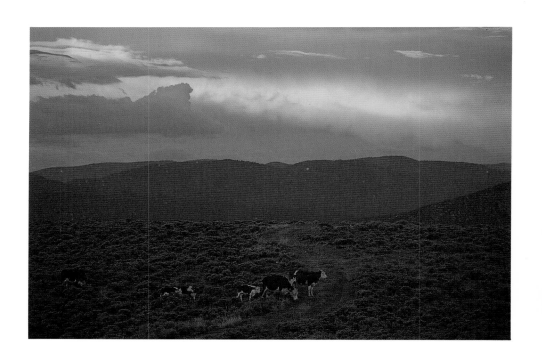

It is not altogether farfetched to state that the destruction of Europe and the Pacific in World War II may actually pale in comparison with the violence we do to ourselves each year in the name of "progress."

Because of chemicals and intensive cash-crop production, the United States is rapidly running out of fertile topsoil for farming. In Arkansas's rice-growing areas, thanks to herbicides which use dioxin, the cancer mortality rate is 50 percent higher than the national average. In California's San Gabriel Valley the well water of nearly half a million people was recently found to contain the lethal industrial solvent trichloroethylene (TCE). In Michigan 97 percent of that state's inhabitants once became contaminated with the toxic chemical polybrominated biphenyl (PBB). In our nation as a whole fifty different insecticides contaminate the drinking water in at least thirty states.

The Soviets aren't poisoning us; we're doing it to ourselves.

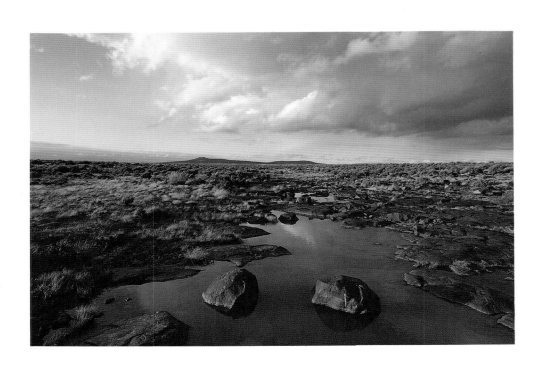

Herman Kahn cites figures proving that 4 percent of our children are already born deformed. And after comparing the horrors of war with the "horrors of peace," he concludes that it is quite possible for decision makers rationally and sanely to go to nuclear war since the effects of an exchange would not be all that different from the negative effects of "civilized progress."

In short, our daily consuming already imitates the aftereffects of a nuclear war.

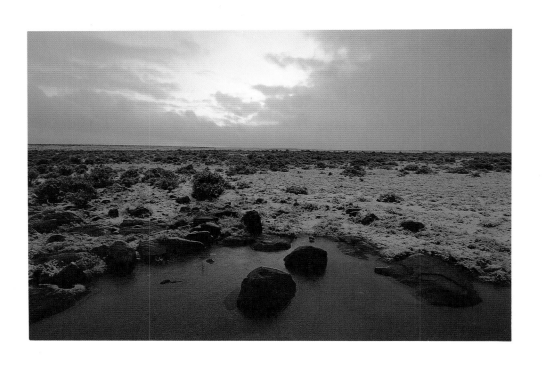

Unfortunately, my home state of New Mexico is high on the list of states which reap huge profits from the development of megadeath capabilities. We are fourth in per capita federal spending, first in per capita procurement contract awards. Most of this revolves around Los Alamos, Sandia National Laboratories, Kirtland Air Force Base, and White Sands Missile Range. A nuclear waste disposal site will soon open up down south near Carlsbad.

It is foreseeable, in the near future, that our state, which arguably has the most beautiful landscape in the nation, may also have the most poisoned landscape (and populace) in America.

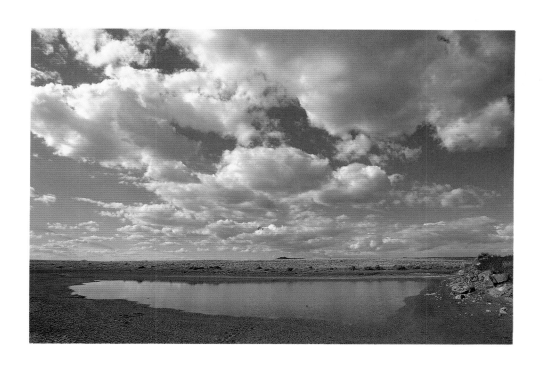

Rachel Carson published *Silent Spring* in 1962. She dedicated it to Albert Schweitzer and quoted him as saying: "Man has lost the capacity to foresee and to forestall. He will end by destroying the earth."

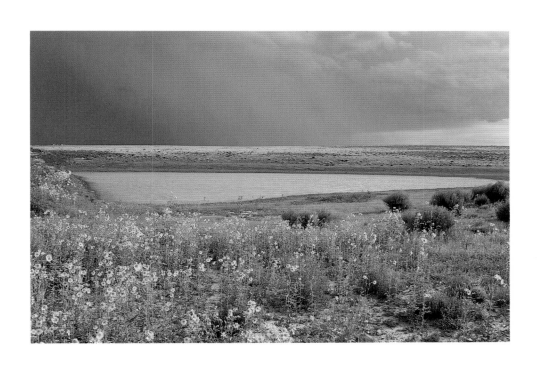

Obviously all the instruments agree: It's already past time for humanity to get its act together and change the way we are piloting our planet (and our own evolution) toward the ultimate holocaust.

But how do we bring about these changes when everything looks so glum?

I mean, here we are, a human society caught in an inhuman century, galloping pell-mell toward planetary suicide. We're all running too fast, and we've lost track of the reasons why we feel it's so important to be running too fast. We are seriously alienated from the origins that got us this far, and, to top it all off, at the heart of our building tragedy is the fact that our sense of awe has atrophied under the stress of modern calamities.

And if that awe goes entirely, what is it that we'll brag about as "distinguishing us from the animals"?

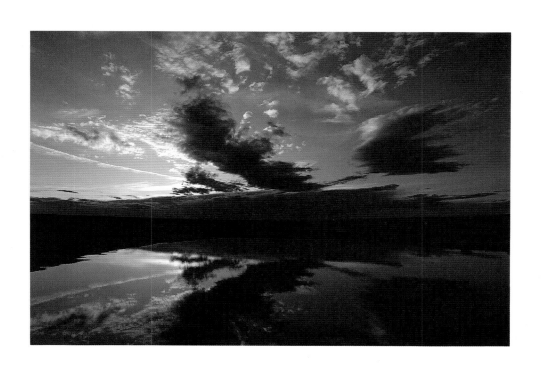

"It seems to me," writes Melvin Konner in *The Tangled Wing*, that "we are losing the sense of wonder, the hallmark of our species and the central feature of the human spirit." And he calls for a reinstatement of amazement and fascination. "At the conclusion of all our studies we must try once again to experience the human soul as soul, and not just as a buzz of bioelectricity; the human will as will, and not just a surge of hormones; the human heart not as a fibrous, sticky pump, but as the metaphoric organ of understanding."

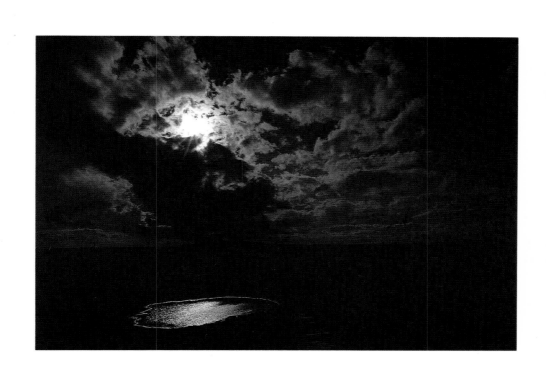

Well, why not?

Konner's admonition seems to me like a great place to begin.

The first step in finding a solution to our problem is developing a desire to solve it. This implies, as a starting point, a reverence for life. And that reverence requires the "awe" Konner is talking about.

Che Guevara once said, "Let me say, at the risk of seeming ridiculous, that a true revolutionary is guided by great feelings of love."

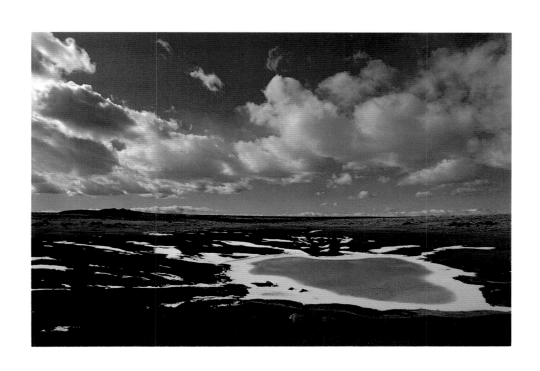

Years ago Loren Eiseley wrote of humanity (which he called "man"): "He must learn that, whatever his powers as a magician, he lies under the spell of a greater and a green enchantment which, try as he will, he can never avoid, however far he travels. The spell has been laid on him since the beginning of time—the spell of the natural world from which he sprang."

It's an old adage that you must understand where you came from in order to know where you are going (and how best to get there).

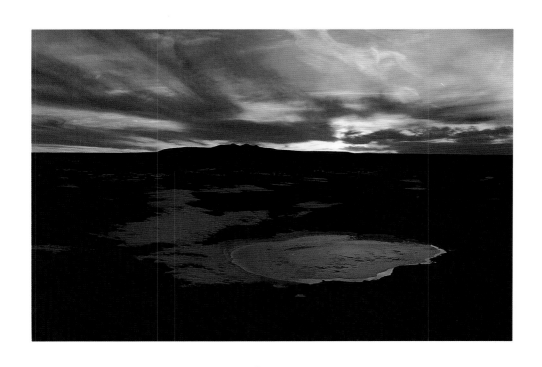

I use this dramatic mesa as a daily reminder of that "natural world from which I sprang." My origins. That landscape which most inspires my reverence for life.

This environment is capable of casting a spell which encourages hopefulness and makes sacred my "sense of place."

No way around it: To save the world, first we must love it.

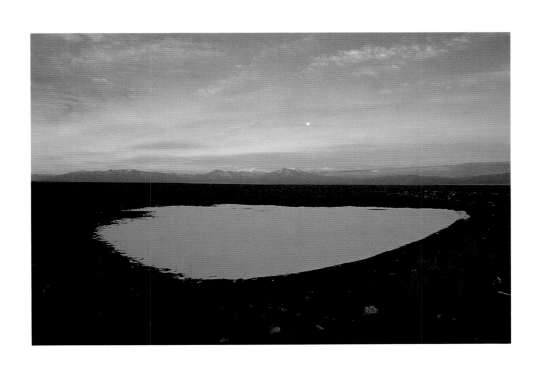

The author of *Crime and Punishment*, Fyodor Dostoyevsky, would have all of us "Love every leaf, every ray of God's light. Love the plants, love the animals, love everything. If you love everything you will sense the divine mystery in things. Once you sense it, you will begin to understand it better every day. And you will come at last to love the whole world."

Unstated, but understood here: Dostoyevsky was really talking about loving ourselves.

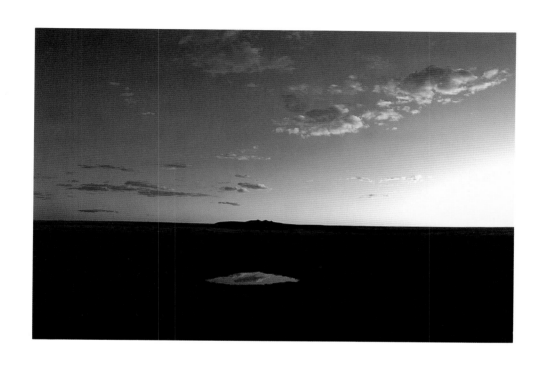

Writes Wendell Berry, in *A Continuous Harmony:* "With the urbanization of the country so nearly complete, it may seem futile to the point of madness to pursue an ethic and a way of life based upon devotion to a place and devotion to the land. And yet I do pursue such an ethic and such a way of life, for I believe they hold the only possibility, not just for a decent life, but for survival."

The kicker here is that even if you live in a concrete jungle and have never seen a blade of grass or an apple tree, everything that sustains your life, from your clothing to your food to the air you breathe is manufactured originally in the natural world—in the oceans, in the wheat fields, and in the forests.

So you owe a lot more than passing homage to the land and to those among us who would preserve it for your well-being.

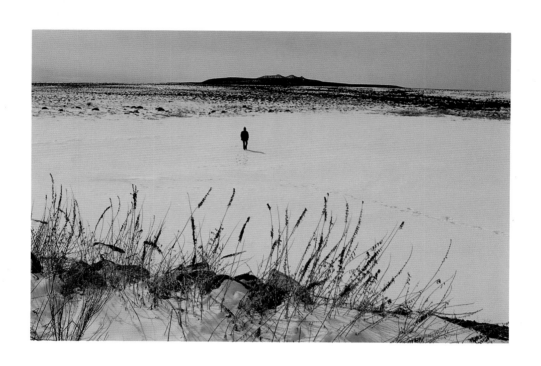

My personal ritual of affirmation begins when I give myself over to the invention of a mesa evening.

The hush out here tickles me. Gravity is doing its suspension act again: Stones, bones, even the water trapped in small puddles among flat black rocks seem on the verge of rising. I picture flotillas of pebbles, like minnows, darting by at knee level. And bones—from an occasional sheep, an unlucky rabbit, an obstreperous coyote—slink quietly along like sleek trout in deep green pools, unconcerned with destinations.

First we must relearn how to *envision* magic; *then* we can wield it.

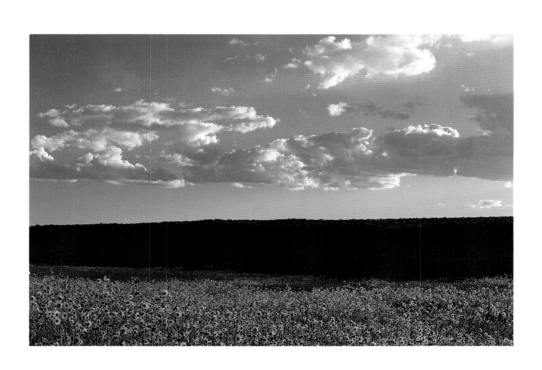

Sometimes, on the mesa, I lie down and wait for the stars to come out. Stretched on my back among ring muhly mounds, I let the sky take over. Almost immediately I feel drowsy. For a moment I can barely keep my eyes open. Arms spread, I relax totally, without apprehensions, open and vulnerable. My head is limp against the earth, and the sky never seemed more wonderful.

It isn't just poisons, now, that enter my lungs. With each breath of the earth's atmospheric membrane I also inhale the breaths of millions of other human beings, animals, birds, fish, algae, you name it. And not just of those things and people alive today. Every second there mingles in me the exhaust of those who have lived, died, breathed, and altered their personal matter into the energy of the atmosphere throughout the ages of history . . . my origins.

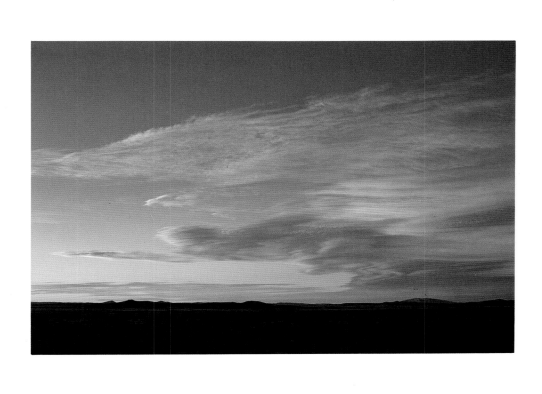

Actually, who's to say of just exactly what this airy membrane consists? Ashes of cremated billions float forever above our heads, among the dust particles kicked up by horses on country roads and tattered flakes of old mosquito wings. We can analyze the various gases, the hydrogen, oxygen, helium; we can isolate the trace metals polluting our air; we can track down and accuse the acid rains distilled from clouds, yet are we approaching even a semidefinitive analysis? Natural gases on top of chemicals released by combustion engines may indeed account for the variety of blues, yellows, and dancing greens that perpetually glorify the oxygen protecting us from being pulverized into a cratered desert by that constant barrage of meteors falling victim to friction long before reaching our topsoil. Yet this envelope of life-granting ether may be charged with an altogether different energy, "a penumbral rainbow" Loren Eiseley once called it, "that cloud of ideas, visions, and institutions which hover about, indeed constitute human society, but which can be dissected from no single brain."

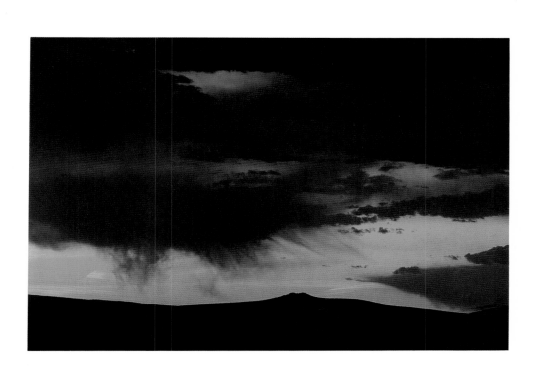

Teilhard de Chardin called it a "noosphere."

A conglomeration, I suppose, of human "souls."

The humanity of Humanity, forever denying impartiality to the air we breathe. Weather made magnificent by human concerns, gods, mythology. The northern lights, rainbows, New Mexico sunsets, and the great cloud migrations across this valley on autumn afternoons made possible, only, by our imaginations.

If we were all taught to regard the air we breathe from such a perspective, would that give us more respect for this gas that daily makes possible all our petty, immoral shenanigans?

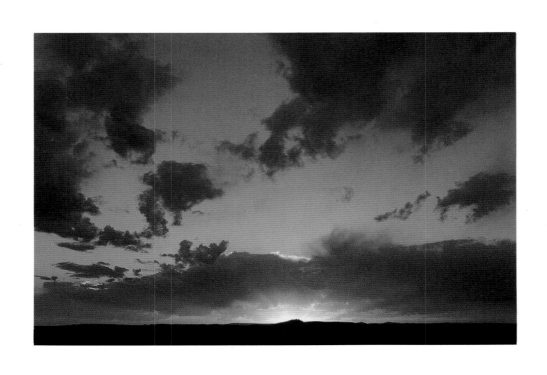

When the first stellar glimmer materializes high above the sagebrush, it is as if a hole has been punctured in my earth-boundedness. Finally, my mind can leap through that pinprick into space, where my origins truly began.

Origin-of-the-universe theories usually describe the condensation of great masses of hydrogen twenty billion years ago, resulting in an explosion that created, in a split second, all the known elements of the universe. Primary among these elements were hydrogen and some helium. Hydrogen today makes up 99 percent of the matter everywhere.

In theory, then, we are all—all living and inanimate things—derived from a common source... that original fantastic catastrophe. All the elements in my body can trace their ancestry back to the beginning of stars. This important fact ought to forge a sense of connection in each and every one of us.

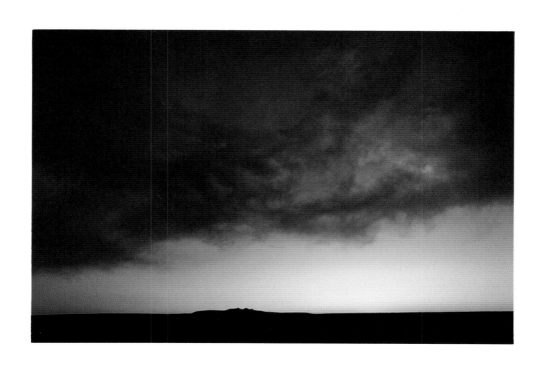

Robert Jastrow elaborates:

"A star is born out of the condensation of clouds of gaseous hydrogen in outer space. As gravity pulls together the atoms of the cloud, its temperature rises until the hydrogen nuclei within it begin to fuse and burn in a series of reactions, forming helium first, and then all the remaining substances of the universe. The elements of which our bodies were composed were manufactured this way, in the interiors of stars now deceased, and distributed to space where these stars exploded."

Vincent Cronin is more specific:

"Our bodies contain three grams of iron, three grams of bright, silver-white manganese and copper. Proportionate to size, they are among the weightiest atoms in our bodies, and they came from the same source, a long-ago star. There are pieces of star within us all."

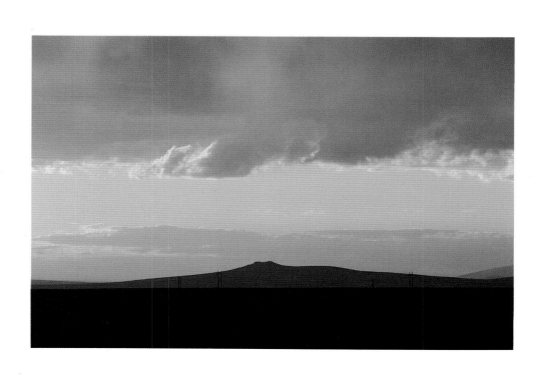

Lewis Thomas presumes that we all derived from some primal cell that may have been fertilized by a lightning bolt long ago. "It is from the progeny of this parent cell that we take our looks; we still share genes around, and the resemblance of the enzymes of grasses to those of whales is a family resemblance."

I.e., there is a direct link between the moon up there and the stars I can now see twinkling in the indigo darkness and a sprig of sagebrush at my knee and the mosquito that just landed on my arm . . . and me.

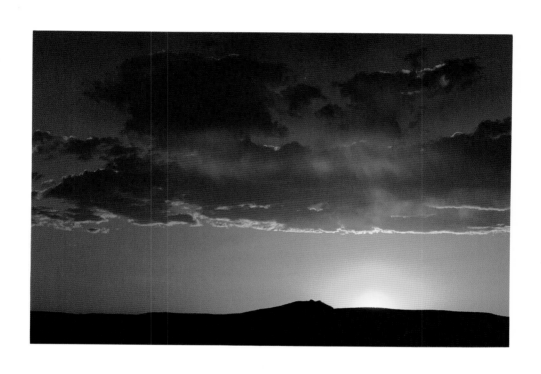

Always my life comes up against the fact that it does not flourish or wane separate from worldwide experience but is, in fact, wired, like a neuron in the brain, to all other circuits of life on earth.

This means that although at times I may flaunt my individuality, I do not exist independent of anything or anybody else. Sooner or later I am intimately affected by the death of a tiger in Burma, the grain prices on a Chicago commodities exchange, the birth of a cold front off the Aleutian Islands in Alaska. Wherever people congregate—in Paris, Bangor, or Beijing—their energy inevitably will lead to a demonstrable effect upon my being. We all are just as intricately wired into the processes of life. Most truly individual freedoms, for example, can be achieved only through a collective uprising. The more we admit this, the wider will be our concerns, the better chance we will have to enhance our own well-being through our involvements with the sociology, economics, politics, and ecology of history.

Conscience, in other words, is collective.

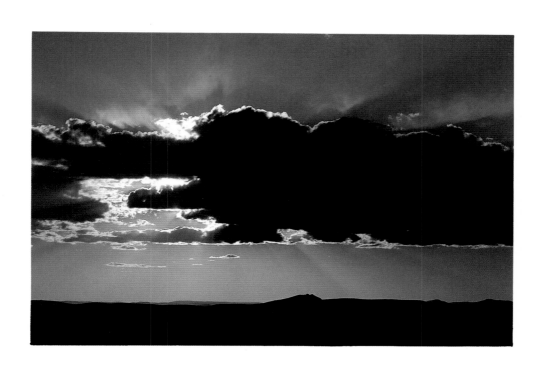

Speaking of conscience, now that the spirit is willing, it's time for a discussion about the logistics of salvation.

The foundation of all my action, of course, is the understanding that any menace to any portion of the biosphere constitutes a personal threat against my own life.

Accepting that truth, no individual should have any qualms about the necessity for social commitment.

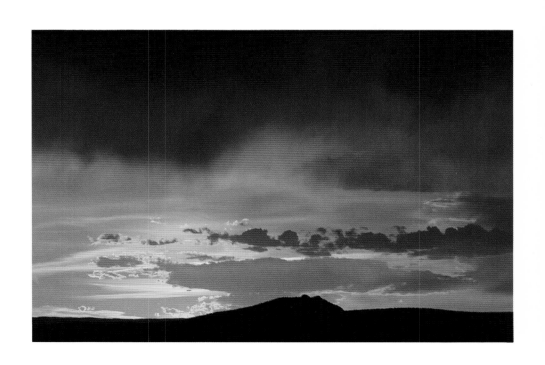

Sometimes I suggest to people, "Don't do it out of compassion for the planet or for other human beings; do it because you're a selfish SOB."

Example: I love to fly-fish for trout on the Rio Grande.

But if I want the river to remain healthy for my personal enjoyment, then I must join all struggles to protect the watercourse. I'll have to lobby the Bureau of Land Management to enforce the Wild Rivers Act. And protest a molybdenum mine tailings pond a half hour north of town which may poison my trout. I'll have to cavil against destructive irrigation practices at the Rio's headwaters in Colorado's San Luis Valley. And I'll need to attend meetings of citizens hoping to moderate the springtime rafting which threatens the habitats of bald eagles and migrating whooping cranes along the river.

Too, since acid rain, pesticides, herbicides, and chemical fertilizers also trash my fishing haven, obviously I'll have to allocate a good bit of my time and energy toward reversing worldwide attitudes about all of *those* things.

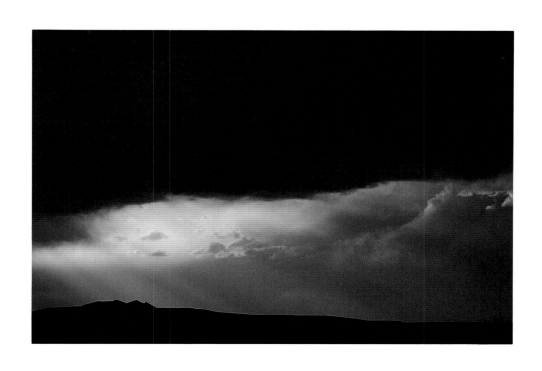

No gesture is too small. A start in saving the world can occur with the simplest changes. Quit smoking; ride a bicycle one day a week; demand organic food; tell your congressional representative to vote no on further contra aid; send ten bucks to Greenpeace, Southern Poverty Law Center, National Resources Defense Council; get a vasectomy after two kids; complain about "Star Wars"; quit putting pesticides, herbicides, lotions, and potions on your lawn; and turn off the air conditioner...forever.

Educate yourself; then educate your neighbor. You don't have to do a lot overnight, but you do have to start. Somewhere, anywhere.

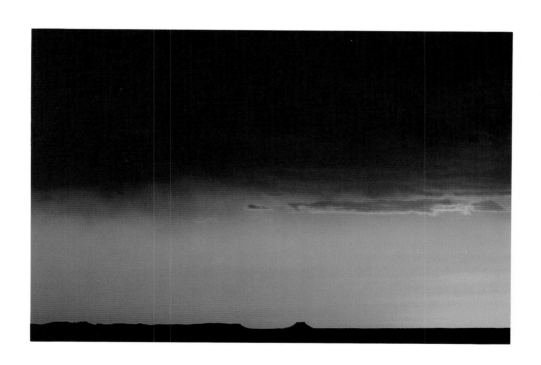

An average car driven one mile creates one pound of carbon dioxide, a major contributor to the Greenhouse Effect. This should be reason enough to walk, pedal, or use public transportation.

Vermont has banned CFCs in auto air conditioners; you should, too. Better yet, the vehicle AC is an accessory we all should do away with, completely.

Replace your incandescent light bulbs with compact fluorescent bulbs. An eighteen-watt screw-in fluorescent bulb is as bright as a seventy-five-watt incandescent bulb and lasts ten times longer. It may cost fifteen dollars but will save you twenty-five to forty dollars in electricity during its lifetime and reduce $CO_2$ emissions in a coal-fired power plant by one ton over that same lifetime.

And plant trees. A tree can absorb forty-eight pounds of carbon dioxide in a year.

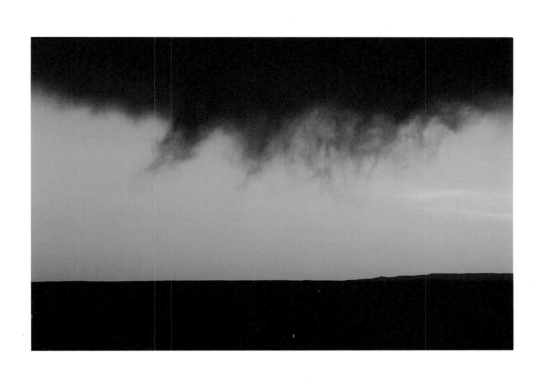

It probably wouldn't hurt to hearken back to some basics. Like, remember how things *used* to be?

When I was growing up in the 1940s and 1950s, our milk came in bottles, and we returned them at the end of the week; the bottles were used repeatedly. Secondhand pieces of aluminum foil were smoothed out, stored in a drawer, and utilized again . . . and again. Coke bottles were like treasures, worth a nickel, and to have smashed one just for the hell of it would have been insane. The diaper service handled the washing chores for my little brothers during their infancy, and when they grew out of their cloth napkins, the diapers were passed on to cousins or to neighbors. A sock egg lay on my mother's dresser; she actually darned the holes in our toes.

And my grandmother really did keep a ball of string.

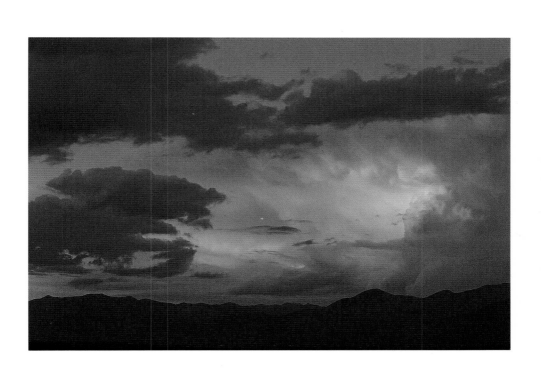

Instead of creating twenty-eight pounds of garbage and toxic wastes each week, maybe we could get it down to two pounds a week. Maybe we could turn everything into compost or recycled goods.

We should demand no more throwaway containers, automobile junkyards, families of six children with three-car garages, a Winnegabo, a Chris Craft, and air conditioning. If a thing can't be recycled, it won't be manufactured. Abortion should be legal, paid for by the state, if necessary, encouraged whenever a family has already attained an officially proposed limit. (China, today, would like to keep that limit at *one*.)

The world population, currently estimated at five billion souls, is expected to double in the next forty years.

We can't afford any more people. Population growth must end. Now. Everywhere.

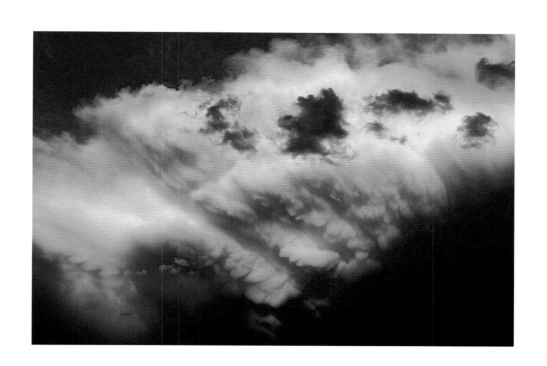

Priorities to work for (worldwide) will be a job and a guaranteed wage for all citizens, socialized medicine, universally adequate housing, decent education for all. Laws aimed at ending large accumulations of money in private hands should be passed. An equal distribution of wealth would do much to alleviate social problems which today threaten every aspect of our society (and the world) and are a major cause of wars and third world pollution.

Once we admit that other societies have an equal right to the earth's resources, we can stop shoring up dictators like Zia, Somoza, Pinochet, and Duvalier, withdraw all aid to South Africa, lift the blockade of Cuba, and support efforts of countries like Mozambique and Namibia to build decent societies free from imperialism's brutal toxins.

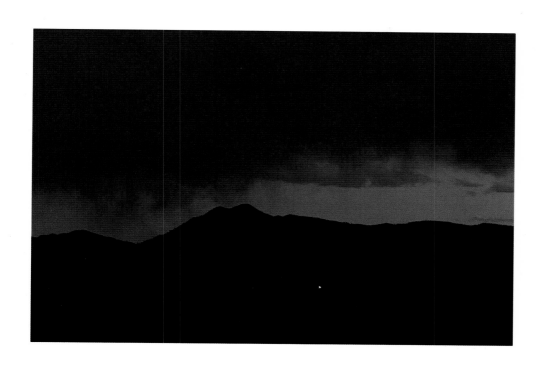

Naturally we must refuse to eat tuna fish until the tuna industry stops slaughtering dolphins. Likewise, we'll have to boycott grapes until growers cease using insecticides which poison their migrant workers.

Perhaps we should stop eating *all* supermarket foods until growers begin to pay their labor a decent wage commensurate with the value of that food to our survival.

Along that vein, maybe we should keep our children out of school until education has become enough of a priority that teachers receive good pay for sharing their precious knowledge.

And we should demand that poor people, as well as rich folks, have the right to a higher education.

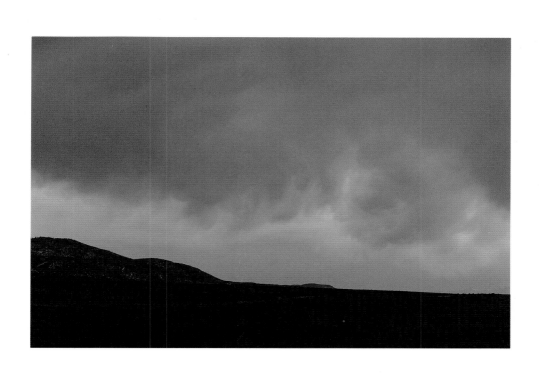

The first principle of life is that everything is interconnected. Hence, any solutions we arrive at which take into consideration only our own families, or our own villages, or our own states, or our own country are, by nature, prejudicial against the rest of the world and ineffective in the long run. North America's destiny, more than that of any other place on earth, affects the destinies of *everybody*. If I admit that the money I pay for my morning coffee is directly connected to the political, economic, and social exploitation of the Colombian peasants who picked the beans that eventually made the java, then I cannot legitimately consolidate my destiny without taking those peasants' lives equally into account. My concern may seem irrelevant right now—after all, I am very privileged, and these peasants are "nobodies." Yet I assure you, for the world to survive, they need to have rights similar to my own. If they don't get them, my son one day may die in an American army uniform in a Latin American country, and what will this lavish standard of living mean to me then?

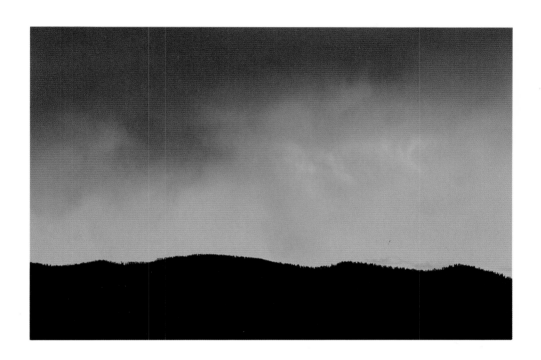

No doubt our standard of living will drop as, having ceased to exploit the countries around us, we will be allowing their natural resources to support *their* own populaces instead of ours, for a change.

A pleasant offshoot, however, is that perhaps we'll wind up a lot less paranoid.

And we may even be able to sleep better at night.

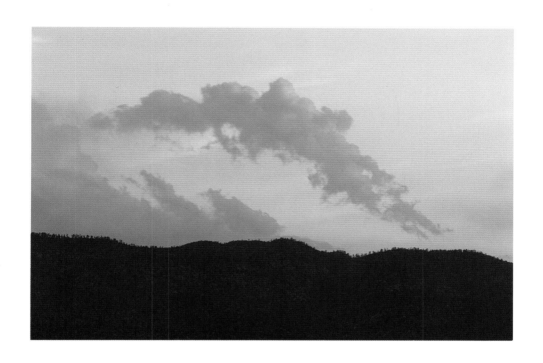

According to playwright Eugene Ionesco, "An individual life is nothing unless it reflects universal life."

It is very difficult for an individual to feel intimate connections with, and a responsibility for, all of humankind. Few of us are willing to admit universal ties and act accordingly, with a compassion that goes beyond blood, village, or nation. It is even more difficult for us to feel a commitment to human history or, in a larger sense, to the evolutionary outcomes of life on earth. Yet this is the task of our survival: to create in everybody just such a social, historical, ecological concern.

That is the one crucial frontier that absolutely needs to be conquered.

Next, we will need to develop positive ways of looking at the world. This will probably seem odd at first for a people conditioned to such a paranoid and cynical world view. But I predict a great national euphoria will be born as we begin to treat one another like intelligent and sensitive human beings, instead of as incompetent nudnicks in a "buyer beware" holocaust incapable of understanding anything more complex than "The Dukes of Hazzard."

Says the poet Walter Lowenfels: "When the tragedy of the world market no longer dominates our existence, unexpected gradations of being in love with being here will emerge."

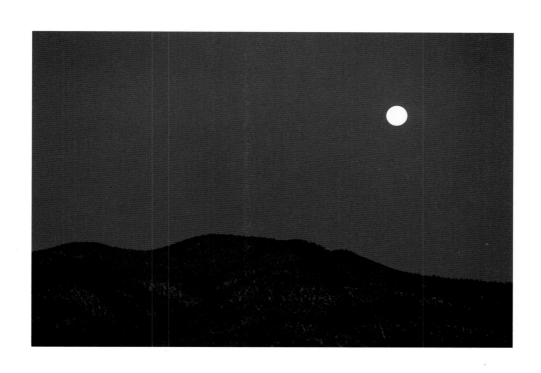

It would not hurt any of us to guide our lives according to the principles espoused in the Shakertown Pledge:

Recognizing that the earth and the fulness thereof is a gift from our gracious God, and that we are called to cherish, nurture, and provide loving stewardship for the earth's resources, and recognizing that life itself is a gift, and a call to responsibility, joy, and celebration, I make the following declarations:

1. I declare myself to be a world citizen.
2. I commit myself to lead an ecologically sound life.
3. I commit myself to lead a life of creative simplicity and to share my personal wealth with the world's poor.
4. I commit myself to join with others in the reshaping of institutions in order to bring about a more just global society in which all people have full access to the needed resources for their physical, emotional, intellectual, and spiritual growth.
5. I commit myself to occupational accountability, and so doing I will seek to avoid the creation of products which cause harm to others.
6. I affirm the gift of my body and commit myself to its proper nourishment and physical well-being.
7. I commit myself to examine continually my relations with others, and to attempt to relate honestly, morally, and lovingly to those around me.
8. I commit myself to personal renewal through prayer, meditation, and study.
9. I commit myself to responsible participation in a community of faith.

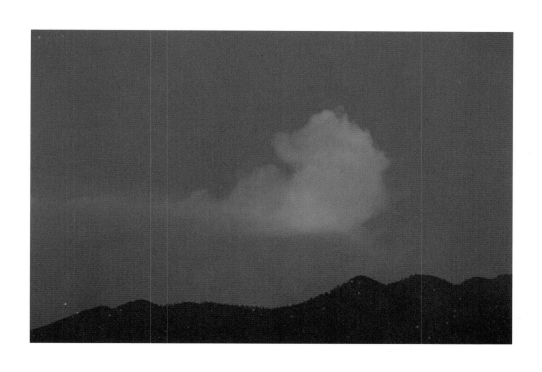

Unfortunately, feeling even halfway positive in this turbulent day and age is not so easy. It takes courage and a lot of work simply *not* to be pessimistic. So many banal evils discourage the growth of a creative vitality. Shadows of malignant scaffolds hold the planet in a very negative net. Yet it can be done. And everything commences by refusing to despair; optimism is my one irrevocable act of faith. All revolutions begin with that act of faith. My dream is never to let *them* make me a cynical old man. My daily struggle is to refuse to buy into all the glittering bleak visions of the slaughterhouse. My struggle is to try never to want what they want me to lust after; my obsession is never to give up and say, "I'm too tired."

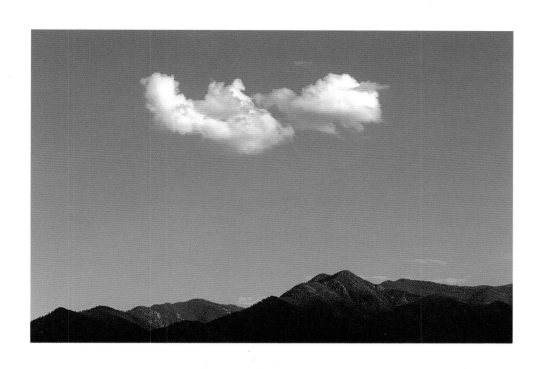

When ecologists in Austin, Texas, struggle to save the black-capped vireo, theirs is a symbolic gesture in defense of all of nature and all humankind. Clearly, anymore, when we destroy the life—of a bird or of another human being—we eliminate an entire universe. Conversely, if we can save a species, reason suggests that that is a step toward our own salvation.

No struggle—for the vireos, for the snail darters, for a Salvadoran peasant, or for the New York homeless—is too small not to have universal implications.

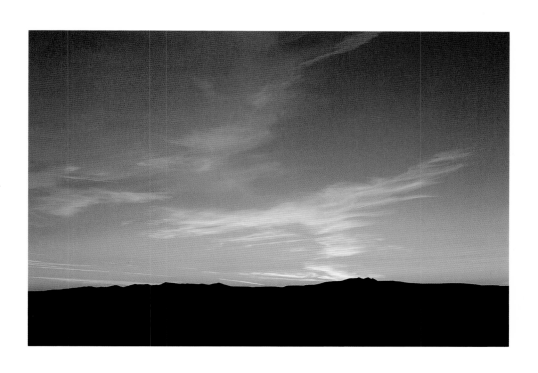

According to Barry Commoner, "The lesson of the environmental crisis is, then, clear. If we are to survive, ecological considerations must guide economic and political ones. And if we are to take the course of ecological wisdom, we must accept at last the even greater wisdom of placing our faith not in arms that threaten world catastrophe, but in the desire that is shared everywhere in the world—for harmony with the environment and for peace among the peoples who live in it. Like the ecosphere itself, the peoples of the world are linked through their separate but interconnected needs to a common fate. The world will survive the environmental crisis as a whole, or not at all."

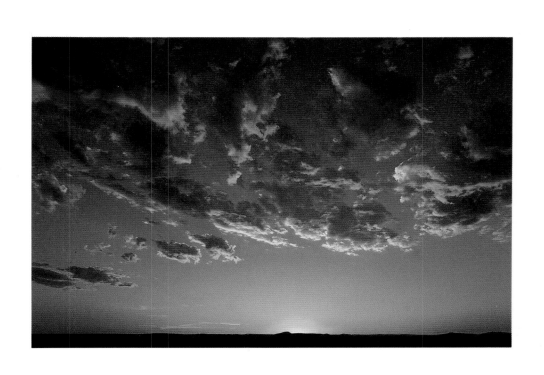

# Notes on a Bibliography

Most of the research materials used for this essay are annotated in the text. Because the work was produced in 1988 and 1989, by the time of publication I'm sure a few facts will be somewhat out of date. Yet if past trends are any indication, I imagine the current state of the planet will be only that much worse. Many books, written long ago, are vitally applicable today, whether they be Thoreau's essays, John Muir's writings, or Rachel Carson's *Silent Spring*. The names of the poisons or the nature of specific onslaughts may have changed, but the results are the same: We continue to destroy the earth.

I clip newspapers daily: the *Albuquerque Journal*, *New York Times*, *Denver Post*, *Christian Science Monitor*. My files run a gamut from Acid Rain and AIDS to Cocaine Wars, Greenhouse Effect, Nicaragua, Ozone Pollution, Perestroika, Star Wars, Toxic Wastes, Unemployment, Whales, Xenophobia. I read countless periodicals, from the *Atlantic* to *Sports Afield*, from *Utne Reader* to *Z Magazine*. Because I make an effort to support organizations concerned with environmental questions, I am regularly inundated by material relevant to the fate of the earth. Publications come from NACLA, Greenpeace, National Resources Defense

Council, Worldwatch, Wild Basin, National Wildlife, Audubon, Sierra Club, Office of the Americas, MADRE, CISPES, Neighbor to Neighbor, Southern Poverty Law Center, the ACLU, Planned Parenthood, Zero Population Growth, and so forth ad infinitum. I have drawn heavily on information received from all these sources.

In the past few years weekly magazines as "mainstream" as *Time* and *Newsweek* (or even the Sunday newspapers' *Parade*) have detailed in considerable depth the damage we have done to the planet. Documentaries broadcast daily on public television are a constant reminder of pending holocaust, as are numerous shows like the *National Geographic* specials which I have always viewed with both awe and alarm. It is impossible, any longer, for a person to be unaware of the crisis. Therefore, a truly detailed bibliography would seem unnecessary. What follows are a few books I have read over the years which state the problem clearly, sound all the relevant alarms, and offer solutions:

Asimov, Isaac.
    *Earth: Our Crowded Spaceship.* John Day Company, 1974.

Berry, Wendell.
    *A Continuous Harmony: Essays Cultural and Agricultural*. Harcourt Brace Jovanovich, 1970, 1972.

Borgstrom, Georg.
    *Too Many: A Study of Earth's Biological Limitations*. Macmillan Company, 1969.

Bronowski, J.
  *Science and Human Values*. Harper & Row, 1965.

Brown, Bruce.
  *Mountain in the Clouds: A Search for the Wild Salmon*. Simon and Schuster, 1982.

  *Lone Tree: A True Story of Murder in America's Heartland*. Crown Publishers, 1989.

Brown, Lester R.
  *The Twenty-ninth Day: Accommodating Human Needs and Numbers to the Earth's Resources*. W. W. Norton & Company, 1978.

Brown, Lester R. et al.
  *State of the World (1984–1989)*. W. W. Norton & Company, 1984–1989.

Carr, Donald E.
  *The Breath of Life: The Problem of Poisoned Air*. W. W. Norton & Company, 1965.

  *Death of the Sweet Waters*. W. W. Norton & Company, 1971.

Carson, Rachel.
  *Silent Spring*. Houghton Mifflin Company, 1962.

Commoner, Barry.
  *Science and Survival*. Viking Press, 1967.

  *The Closing Circle: Nature, Man, and Technology*. Alfred A. Knopf, Inc., 1971.

  *The Poverty of Power: Energy and the Economic Crisis*. Alfred A. Knopf, Inc., 1976.

Dillard, Annie.
  *Pilgrim at Tinker Creek*. Harper's Magazine Press, 1974.

Dyson, Freeman.
  *Disturbing the Universe*. Harper & Row, 1979.

Eiseley, Loren.
　　*The Immense Journey.* Random House, 1956, 1957.

　　*The Invisible Pyramid.* Charles Scribner's Sons, 1970.

Ehrlich, Paul and Anne.
　　*The Population Bomb.* Sierra Club/Ballantine, 1968.

　　*Extinction: The Causes and Consequences of the Disappearance of Species.*
　　Ballantine, 1981.

　　*Earth.* Franklin Watts, 1987.

Falk, Richard A.
　　*This Endangered Planet: Prospects and Proposals for Human Survival.* Random House,
　　1971, 1972.

Galeano, Eduardo.
　　*Open Veins of Latin America: Five Centuries of the Pillage of a Continent.* Monthly
　　Review Press, 1973.

Jackson, Wes.
　　*Altars of Unhewn Stone: Science and the Earth.* North Point Press, 1987.

Krutch, Joseph Wood.
　　*The Desert Year.* Viking Press, 1951,1952.

　　*The Voice of the Desert: A Naturalist's Interpretation.* William Morrow and Company,
　　1954, 1955.

Leopold, Aldo.
　　*A Sand County Almanac.* Oxford University Press, 1949.

Linton, Ron M.
　　*Terracide: America's Destruction of Her Living Environment.* Paperback Library, 1971.

Marx, Wesley.
  *The Frail Ocean*. Coward-McCann, Inc., 1967.

  *The Oceans: Our Last Resource*. Sierra Club Books, 1981.

McPhee, John.
  *The Curve of Binding Energy*. Farrar, Straus, and Giroux, 1973, 1974.

Montague, Katherine and Peter.
  *No World Without End: The New Threats to Our Biosphere*. G. P. Putnam's Sons, 1976.

Muir, John.
  *Wilderness Essays*. Peregrine Smith, Inc., 1980.

Nearing, Helen and Scott.
  *Living the Good Life: How to Live Sanely and Simply in a Troubled World*. Schocken
  Books, Inc., 1970.

Rienow, Robert, and Leona Train.
  *Moment in the Sun: A Report on the Deteriorating Quality of the American Environment*.
  Dial Press, 1967.

Ridgeway, James.
  *The Politics of Ecology*. E. P. Dutton & Co., 1970.

Schumacher, E. F.
  *Small Is Beautiful: Economics As If People Mattered*. London: Blond & Briggs Ltd.,
  1973.

Shepherd, Jack.
  *The Forest Killers: The Destruction of the American Wilderness*. Weybright and Talley,
  1975.

Smith, W. Eugene and Aileen M.
  *Minamata*. Holt, Rinehart and Winston, 1975.

Thoreau, Henry David.
    *Walden and on the Duty of Civil Disobedience*. Holt, Rinehart and Winston, 1961.

    *The Natural History Essays*. Peregrine Smith, Inc., 1980.

Union of Concerned Scientists
    *The Fallacy of Star Wars: Why Space Weapons Can't Protect Us*. Random House, 1983,
        1984.